OPEN-ENDED ART FOR YOUNG CHILDREN

Open-Ended Art
for Young Children

TRACY GALUSKI, PHD

MARY ELLEN BARDSLEY, PHD

Redleaf Press®
www.redleafpress.org
800-423-8309

Published by Redleaf Press
10 Yorkton Court
St. Paul, MN 55117
www.redleafpress.org

First edition 2018
Cover design by Jim Handrigan
Cover photograph by Terry's Photo Studio
Interior design by Erin Kirk New
Interior photos on pages x, 13, and 18 © The Strong, Woodbury School,
 www.museumofplay.org/education/woodbury-school. Reprinted with
 permission of © The Strong. All rights reserved.
Image on page 75 by Piet Mondrian.
All other images by Tracy Galuski and Mary Ellen Bardsley
Printed in the United States of America
25 24 23 22 21 20 19 18 1 2 3 4 5 6 7 8

Library of Congress Cataloging-in-Publication Data
CIP data is on file at the Library of Congress.

Printed on acid-free paper

This book is dedicated

to all the wonderful teachers

who take the time to see the beauty

in messy moments.

CONTENTS

ACKNOWLEDGMENTS

The development of this book has been a long journey inspired by many people. First, we want to thank our parents, who provided us with early opportunities to create messy art and taught us the value of learning. Next, we thank our supportive husbands, Larry and Jim, who continue to tolerate unusual collections of art supplies such as cardboard, ribbon, and other stuff because it might be cool in an art area. We also thank our children: Genevieve, Erik, Kathleen, and Emily, who were our inspiration and confirmed what we knew were best practices for young children. From reading children's books and visiting art museums to shared moments at the kitchen table with glue and collage materials, their work continues to inspire.

We would like to thank the editors and staff at Redleaf Press, especially Kara Lomen, who saw the potential for this book and encouraged us to submit a proposal. Thank you for your support and continued guidance as we put our ideas to paper.

Finally, we'd like to thank the early childhood educators who have inspired and encouraged us. Carol and Lynnette, who participated in our original conversation regarding art, and the early childhood community in Western New York, who continues to reach out to and engage professionals in conversations, all of whom have been a source of inspiration and support. Special thanks to the programs who opened their doors to us to view and photograph art experiences: Buffalo State Child Care Center, Edukids, Inc., Kandyland Kids, Inc., LaSalle Early Childhood Center, Inc., the University at Buffalo Child Care Center, and Woodbury School at the Strong. This book would not exist without the encouragement and support of these special people.

INTRODUCTION

Years ago, I recall having breakfast with my early childhood friends and colleagues Mary Ellen, Carol, and Lynette at an early childhood conference in Verona, New York. We were discussing the keynote address and popular training sessions, including one about open-ended art. This form of art, also known as creative art or individual art, offers the best opportunity for children to explore and create. After years and years of attending the NYAEYC statewide conference, this group of professionals wondered why the same topic was still being offered. Hadn't everyone heard about open-ended art by now? We agreed that open-ended art was important and started to list some of the potential barriers that we suspected might prevent teachers from applying developmentally appropriate practice in the form of open-ended art in their classrooms. From that early discussion, several things emerged, including a research study, an article, several conference presentations, and finally this book.

Open-Ended Art for Young Children explores the challenges experienced by practitioners and offers some solutions to explain the *hows* and *whys* behind professional practices related to art curriculum and activities. It is based on our experiences as a child care provider, program administrator, training specialist, college professor, and years of observation and experience with practitioners in the field.

This book is written primarily for the teachers who develop the day-to-day activities in early care and education programs and the administrators who help them ensure high-quality programs. While we refer to teachers and practitioners throughout the book, these terms include everyone who works with children, whether defined as teachers, aides, assistants, caregivers, or early care and education professionals. Teachers of children from birth through age eight will find a wealth of information and practical suggestions to use with the children in their care, including examples of how to modify activities based on the age of the child.

The book is divided into three main parts. Part 1 describes an overview of planning for art curriculum and instruction. This section provides some background information about planning a classroom environment that includes open-ended art. Part 1 also features information about defining the purpose of art, so you can develop learning outcomes that support developmentally appropriate activities. Part 2 reviews child growth and development for infants,

toddlers, preschoolers, and school-age children and offers practical examples of art activities for each age group, including how to integrate art appreciation into regular activities. Part 3 reviews different art mediums and techniques with multiple examples of sample activities that can be applied to a classroom setting to provide new and different challenges for young children. Throughout the book, we discuss the ways you can support the culturally diverse children in your classroom and their families. At the end of each chapter, a reflective activity or investigation is provided. The purpose of these activities is to encourage readers to reflect on the key points of each chapter and to begin thinking about how concepts can be applied to early childhood classroom settings. The book also includes recommended children's books and resources for further exploration.

We hope you find the following pages insightful and challenging!

PART 1

Planning the Environment

Getting Started: What Is Art?

Marta likes art, but sometimes she feels like she should be doing more in her classroom. Every day she does her best to plan art activities for the children, but it seems like they're doing the same things over and over: bingo daubers, marble painting, and tempera paint. She often wonders what she's missing.

When it comes to young children, adults tend to focus on what the children are doing, rather than on what they are expressing. Creative art is defined by so much more than the final picture or project. Art is something that comes from the heart. It is created with an imagination combined with some techniques that allow the artist to express feelings and inner beauty. The field of early childhood education has long recognized and supported art, and has for decades discussed the value of open-ended art, yet structured crafts persist. This chapter explores the foundations of creative art, including the difference between open-ended art and structured crafts, or closed-ended art; outlines some guidelines for creating lessons and activities around open-ended art within the context of developmentally appropriate practice; and art appreciation for young children.

Open-Ended Art

Open-ended art is defined as an art activity where children are free to use their imagination as they explore a variety of materials without a specific expectation of what the final product will look like. The terms *open-ended art* and *creative art* may be used interchangeably because both enable children to freely express themselves with their chosen medium. Keeping the age of the children in your group in mind, you would provide a variety of art materials in the room and allow the children to explore them. Items could include several colors of paint; several types of glue and a wide variety of collage materials; tools such as tape, scissors, and staplers; and sensory materials such as clay or modeling dough. Materials would be self-selected by the children, which means the children have the freedom to decide what materials inspire them from one day to the next. One day they might select a few colors of paint and a wide brush, and the next day they might select the glue and an assortment of collage materials. New media would be introduced as children develop new interests and are taught different ways to use the materials. For example, a teacher might introduce chalk pastels

or watercolor pencils and then show the children how to use them as they explore the colors of the rainbow. After the materials are introduced, the children may use them to create their own individual artwork.

When teachers embrace open-ended art, they focus on not only the process of creating art but also on the children's developmental abilities. They observe how the children hold the paint brushes and control the long lines up and down the paper. They notice how letters and shapes begin to emerge. They observe the

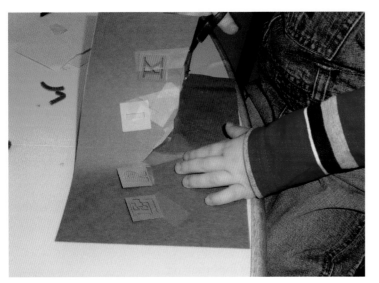

developmental stages as a child moves from painting simple stripes to painting a head attached to nothing but very long legs to painting a more realistic picture that includes a rounded body with fingers and toes. Over time, the children develop the skills to explore important ideas and feelings through art. Teachers might observe a child painting a large face with a smile or angry-looking soldiers in a battle scene. Open-ended art gives children an important opportunity to think, feel, and express ideas. It allows teachers and children to slow the pace and to observe and feel the environment around them.

Closed-Ended Art

In contrast, closed-ended art, also described as *structured projects* or *crafts*, offers a very different experience. The teacher might provide prepared materials and a model of something related to the season or theme, or they might provide some instruction about how to make something. During structured art activities, certain aspects of the situation are tightly controlled, such as the time allowed, the work space, or the specified materials. Even if the teacher allows the children to use the provided materials in a flexible manner (for example, allowing the children to place the teacher-selected materials anywhere they want on a piece of paper), the overall situation is typically controlled by the teacher. Closed-ended art places emphasis on the final product; that is, what the artwork should look like when it is finished. For instance, the teacher shows the children how to make a lion out of precut pieces of construction paper, then gives them fifteen minutes to complete their lion before lunch. In the twentieth century, this was considered a "rote orientation to visual arts" (Gunn 2000, 153). These carefully structured experiences were part of a practice known as *tabletop activities*, and they are still prevalent today despite professional recommendations that encourage a shift to creative art.

With so many things that need to be squeezed into a busy day, early childhood classrooms tend to function by the clock as teachers move children from activity to activity while working around breakfast, gross-motor activities or outside time, lunch, and caregiving routines. As a result, it's easy to be more concerned about what children produce and to focus too little on the ideas children present and share.

Developmentally Appropriate Practice

While it may seem as though open- and closed-ended art define two ends of a continuum, it's not as simple as declaring open-ended art to be "right" and closed-ended art to be "wrong." Developmentally appropriate practice requires educators to think about the complexity of and interrelationship among the principles that guide early childhood practice (Copple and Bredekamp 2009). When deciding whether art is open ended or closed ended, many variables need to be considered, including how an activity is introduced to the children, the choices that are given to the children to make, and the role of the teacher throughout the process. For example, a teacher might introduce a collage activity using a number of collage materials based on the theme. Since the teacher has added some structure to this activity, but hasn't prescribed its outcome, it's not completely open ended or completely closed ended. Instead, the collage activity would fall somewhere in between. While open-ended art is what is preferred, there are many art experiences in the middle of the continuum that provide opportunities for individual learning.

Please note that a child's artwork cannot always be judged after the fact to determine whether an art activity was open ended. Without understanding the context of the situation in which the artwork was completed, it's possible to make inaccurate assertions. For example, a person might view a display of nine similar orange pumpkins on a bulletin board. At one end of the continuum, the pumpkins could have been completed by the children in a structured manner with the teacher instructing the children on exactly what to do and handing them the orange paint. At the other end of the continuum, the children could have been exploring still life paintings. They could have been imitating the style of a specific artist as part of a fall theme that included close study of pumpkins. Based on the display, without more information, the person viewing the finished pumpkins wouldn't know if they were an open-ended activity, a closed-ended activity, or somewhere in the middle.

Even when educators encourage creative art experiences in the form of open-ended art, some children may do the same thing over and over until a teacher steps in to offer new ideas, suggestions, or techniques. Some children may benefit from additional teacher instruction or support in the art center.

Offering children more instruction or support does not require teachers to promote closed-ended crafts, however, with all the children completing the same project the same way. It does require educators to promote art experiences that support children's growth and development. How teachers define the concept of product within the context of daily activities makes a difference. When teachers think of product, are they simply asking each child to paint the exact same thing, or are they emphasizing the way the children use the new watercolor paints, and noticing how the children have learned to carefully blend the colors to make an interesting effect? Researchers Earl Linderman and Donald Herberholz (1969, iv) did a lot of foundational work on art and perceptual awareness, and provide insights on the product and the process:

> The notion of process and product might better be thought of as inseparable. A weak product is merely a record of a poor process, which in turn may be the result of diffuse motivation. On the other hand, a good product is the record of a strong period of process and high motivation. This whole matter is further complicated by the fact that the teacher is expected to be a skilled and mature person whose job it is to assist each child to attain levels of achievement that he might not otherwise reach.

When the process is emphasized with very young children, teachers should think about what the children are learning as they swirl and whirl the paint

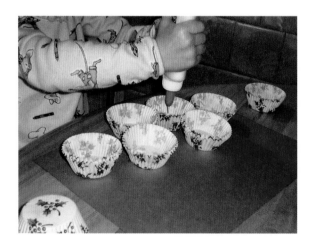

across the paper. The process is important—but so is the final product. As the children grow and develop, they begin to focus on what they have produced. Teachers do not need to view the process and the product as contradictions but as integral parts of the same activity. Perhaps what teachers need to ask is, "How did the child get to that final product?"

Some teachers may feel that children are not able to complete a project that meets the teachers' goal for the day, so they give the children specific materials to help them make a planned project that is "cute" or "pretty."

But when children are instructed to glue several precut pieces of orange and yellow paper together on a paper plate, with the expectation that the final product will be a lion, it probably takes little effort on behalf

of each child. When this happens, the emphasis of the work is put solely on the product, or what the project will look like when it is complete. The child might say, "The teacher wanted me to make a lion." This child recognizes that she made the lion, but she also knows she didn't make any decisions regarding the lion.

A good process will accomplish a good product over time, such as the child who picks up a paint brush at the easel and delicately pulls the brush down the paper in swirls of oranges and yellows and stands back to admire the long lines that remind him of a lion's mane. As toddlers grow into preschoolers, those long lines will begin to take shape, and something that resembles a lion will emerge.

Early childhood professionals need to shift how the final art product is defined and valued. Do teachers, families, and children value a paper plate lion over golden swirls and whirls on plain white paper? Teachers may like the look of ten lions posted on the bulletin board, and parents may smile as they find the one made by their child, but how do the children feel about a project that took little effort on their part?

Building a Foundation for Art Appreciation

Art appreciation requires some knowledge and understanding of the qualities and techniques that great works of art exemplify, but anyone can begin to appreciate art. Teachers can help children build an awareness and appreciation of art by developing some of the foundational skills in themselves. To that end, it's helpful to start with some personal reflection about art experiences.

Say you were handed a piece of paper and asked to draw a house. What would you create? Pause for a minute and imagine the drawing. Would your picture depict a small square dwelling with a triangle roof and a sidewalk that curved to the left? Would you top the chimney with a dramatic swirl of smoke? When you really think about it, does your vision resemble the place where you live? Does it look like any of the houses in your neighborhood? How did you decide that your house would be square with a curved sidewalk and swirl of smoke? What if you don't live in a house but in a city apartment building or a mobile home or a large rural farm? Where does the image of a house come from?

As you pause to reflect, challenge yourself to think about how your representation of a house may have come from the personal experiences you had as a child. At some point during those early childhood experiences, you were taught how to draw a house, just as your teacher was taught how to draw a house. The problem is that professionals teach young children how to draw and create things based on their own personal experiences rather than on the child's personal experiences, which are probably very different.

Children are born with an intrinsic awareness of the beauty around them. They take in experiences without immediately judging and labeling them. Picture a young child standing over a puddle of water in the driveway. As the parent steps over the puddle and attempts to rush the young child to the car, the child stops and squats down to admire the beauty of the water. While the parent has judged it to be a mud puddle with nothing special to admire, the child notices the colors that dance as the water ripples, the tiny pebbles glistening at the bottom.

Before anyone can cultivate this intrinsic awareness in young children, they need to revisit their own experiences. As a toddler, you probably picked up crayons and drew large swirls across the paper. You probably scribbled lines and made dots. Someone close to you probably made remarks and commented on your work. Over time your creative mind was shaped by these experiences. How did your art experiences change as you entered preschool and then elementary school? Were you encouraged to work at an art easel, or did someone give you materials and a product to complete? Did you have free access to the art center and easel, or were they always closed and facing the wall?

When adults reflect on personal experiences around art, it encourages the development of a deeper awareness of the shapes, colors, and light that are experienced every day. Think about that little square house with the swirl of smoke. When was the last time you stopped to look at the shapes and lines of a house? You might notice the long horizontal lines created by the siding, or the perfect triangles created by the roof. Perhaps you notice the moss that creates a trail of green along the stone path or the perfect rectangles created by the rows

of bricks. This simple example encourages you to develop an awareness of the beauty around you. Go out for a walk with the children. As you notice things along the way, take time to point them out to the children. Ask them to point out all the triangles they see along the path, or to spot the largest or brightest flower. Observing the beauty in everyday items builds a foundation for art appreciation.

Personal Reflection and Practice

Prepare: Using a simple pencil and paper, draw a picture of a flower.

Act: Now, visit a garden or stop at the flower shop on the way home from school or work and treat yourself to a bouquet of flowers. Place the bouquet at the center of your dinner table and observe the flowers for at least two minutes. What do they look like? What shapes do you notice? How many petals are there? Select one of the flowers to focus on. Develop a list of the things you notice about it. Not knowing what all the parts of a flower are called is okay; you can look up the names later. Now take about ten minutes to draw another flower based on your observation.

Reflect: Compare the two flowers and reflect on them. What is similar about the flowers? What is different? How does this relate to open-ended art?

Note: This simple activity can be done in a classroom setting with a wide variety of materials. The children can observe flowers, fruits and vegetables, or a wide variety of props. Add the items to be observed in the art center, as a centerpiece on the lunch table, or to the science center with a few magnifying glasses.

Planning for Art: Aren't We Supposed to Make Projects Related to Our Theme?

Every Monday Tamika plans an entire week of art activities related to the theme. Last week the children in her classroom were learning about farms, and this week Tamika has decided to plan around the topic of apples. In the art area, she has come up with several activities, including coloring apples, making red tissue paper apples, and construction paper apple trees. Tamika cut out red circles to glue onto the construction paper trees. She even cut out twelve little worms for the children to add to the pictures. But her administrator was not impressed and asked Tamika to think deeper about the topic. Now she's confused.

Teachers typically plan activities based on a specific curriculum model, or develop activities based on a combination of models. It's common for teachers to break the curriculum down in the form of a planning grid, chart, or lesson plan. They may begin with a theme and then brainstorm a list of potential activities, including art activities, to provide related to the theme. The final plan might be posted on a bulletin board to share with parents. While a theme may offer an excellent starting point, this chapter explores the fundamentals of planning for art as curriculum and offers alternatives to a planning process that reduces art to a series of structured, theme-related projects.

Curriculum Models

Some early childhood programs utilize popular curricular models, such as the Creative Curriculum, Montessori, Reggio Emilia, or HighScope. In these programs, the activities teachers plan are based on the theoretical underpinnings of the specific curriculum model. Other early childhood programs follow a basic curriculum that is provided by the program's main office or the school district in which the program resides. Finally, some programs do not follow any specific curriculum model but use a combination of models and develop topics or themes on a weekly or monthly basis that are based on the needs or interests of the teachers or the children. Whatever method a program chooses, it's important

for teachers to take some time to think about the curriculum. The National Association for the Education of Young Children (NAEYC) provides a position statement related to planning curriculum, the *Early Childhood Curriculum, Assessment and Program Evaluation*, which sets the foundation for what is developmentally appropriate by listing the indicators of effective curriculum planning for children from birth through the primary grades (NAEYC and NAECS/SDE 2003, 2):

- "Children are active and engaged."
- "Goals are clear and shared by all."
- "Curriculum is evidence-based."
- "Valued content is learned through investigation, play, and focused, intentional teaching."
- "Curriculum builds on prior learning and experiences."
- "Curriculum is comprehensive."
- "Professional standards validate the curriculum's subject-matter content."
- "The curriculum is likely to benefit children."

These indicators are helpful as teachers determine how art activities can be used to support and enhance the overall program curriculum.

Intentional Teaching

Intentional teaching begins with knowledge of child development and the skills that are appropriate to the age of the children in the classroom. Based on the typical developmental stages and age-appropriate expectations, teachers should establish learning goals for the children and put together plans for how the goals might be accomplished as children work to master skills. Teachers know that in an early childhood setting, the children will all be at very different developmental stages in the domains of language, cognitive, social-emotional, and physical development.

When teachers know and understand the children in their care, they can set up the environment to meet the children's varied needs. A teacher might encourage one child to write a shopping list in the dramatic play area and encourage another child to sort the blocks by shape. Each child is working on different skills under the watchful eye of the teacher, who observes each child, takes notes, and plans activities to scaffold their individual learning. Most classrooms have some version of an art center available, and an intentional teacher will add and rotate art items on a regular basis to meet the needs of all the children in the classroom.

Intentional teaching can also be spontaneous, taking advantage of the learning that emerges from activities. Art offers a great opportunity for spontaneous teaching and learning because anything might transpire from the open-ended experiences. As the paint touches the paper and shapes and patterns materialize, the teacher might focus on any number of skills, such as showing a child how to manipulate a paintbrush as they are developing motor skills, or helping a child use words to describe what she's doing as they are developing language skills.

MAKING TIME FOR ART

Beginning with toddlers, recommended learning centers include science and math, sensory (such as sand and water), manipulatives (such as lacing cards and puzzles), dramatic play, blocks and building, literacy (a book area with comfortable furniture), and, of course, art. When children have opportunities to self-select activities, they feel empowered. Large blocks of uninterrupted time are preferred over short scheduled chunks of time, where children are limited in what they can do and expected to move as a group from one activity to the next. The exact amount of time available in the learning centers depends, however, on the length of the day, the program schedule, and numerous other factors. But large blocks of time allow children to slow down and think about the materials they are using.

In terms of art, think about how long it might take someone to come up with an idea and develop a plan, gather the materials needed to carry out the plan,

and then complete the work. Depending on the age of the child and the child's ideas, it could take anywhere from five minutes to an hour. One child may need only a few minutes to color a simple drawing before being ready to move on to a different activity, while another may take an hour because he is so deeply involved in the process. Regardless, each project results in the creation of art that serves a unique purpose for each child.

Pretend you've found an old wooden door in the neighbor's trash and you remember seeing an idea in a magazine that you'd like to try. With the right materials, you can turn the old door into a large coatrack and display for your hallway. All you need to do is sand the door, paint it red, and attach some colorful knobs to serve as coat hooks. You know that all the materials are readily available in your basement storage room, but you have only twenty minutes to complete the plan. Is that enough time? Will you begin the project anyway, or will you set it aside for a day when you have more than twenty minutes to do the work from beginning to end?

Limited time or too much structure can hinder creativity. As an adult, what do you need to fully plan, prepare, and compete an activity such as the large coatrack display? Let's imagine you decided twenty minutes was enough time to complete the coatrack project, so you got right to work. With only a couple more knobs left to attach before the project was complete, however, someone announced it was cleanup time. What would you do? Would you quit and return all the materials to their proper place in the basement, knowing you might never get back to the project? Or would you stall a few minutes to complete your work first? Now take a moment to put yourself in the child's shoes.

Large blocks of time allow children the freedom to work through a plan, master a technique or concept, or compete a project they are proud to share. Large blocks of time allow children to work through a process at their own pace, rather than on an adult's timeline. In addition, more time allows materials to dry or set and gives children an opportunity to think about the next steps. Recently we observed a preschooler in her classroom. The teacher was encouraging her to clean up her art project, but the child pretended not to hear as she continued to push short pieces of straws through the holes she had punched into a piece of paper. Think about what was running through her mind as she pushed straw after straw through the line of holes she had punched in paper. The teacher continued to call her over to the group time in an increasingly stern voice. After just a few more minutes, the child stood up, looked at her paper with a confident smile, and placed it in her cubby to take home. She had planned the activity, gathered materials, and needed only a few more minutes to complete her work before she was ready to move on. If you were this child, and you just needed a few more minutes, what would you have done?

There could be several solutions to the scenario. One teacher might give the child a few more moments to complete the task and let her join the group activity when she was done. Another teacher might offer her a tray or container to store the materials in to complete later. Yet another teacher might reflect on this event and determine the child needs more warning before cleanup. There are many possibilities, and as you decide what would be appropriate for the situation, think about how you prefer to draw closure to your own activities.

DEVELOPING THE ART CENTER

Now it's time to develop a room arrangement that facilitates art. The art center is an active learning center, so placement is important. It should be near a sink or bathroom, with flooring material that is easy to clean. In child care centers, art often takes place on the tables that are used for lunch or snack. These tables create an excellent workspace for children if all the art materials and art easels are placed nearby. The focal point of an art area should be a low shelf containing materials that are easily accessible to children.

A nationally recognized rating scale, the *Early Childhood Environment Rating Scale* (ECERS-3) (Harms, Clifford, and Cryer 2014), defines five categories of materials that are essential to an art center: drawing materials, paints, three-dimensional materials, collage materials, and tools. Drawing materials include items such as crayons, pencils, watercolor markers, and chalk. Paints typically include tempera, watercolors, and finger paints, along with a wide variety of painting tools, such as pipettes, cotton swabs, cotton balls, flyswatters, cooking utensils, and even toothbrushes. Three-dimensional materials include

cardboard scraps and boxes (large and small), wood scraps, pipe cleaners, playdough, slime, and clay. Collage materials could be cloth scraps, yarn, foam shapes and textures, tissue paper, wallpaper scraps, stickers, googly eyes, and fabric. Tools such as scissors, staplers, tape dispenser and tape, hole punches, rulers, clipboards, and stamps with pads are great additions.

CREATING INSPIRATION

Teachers have an opportunity to regularly add something new and interesting to the art center to inspire the children with new ideas. But "new" and "interesting" don't always mean changing the materials and tools. In fact, children benefit from regular use and availability of materials and tools. "New" and "interesting" can refer to meaningful models such as a seasonal flower arrangement, a piece of driftwood, or a handwoven basket that encourages a new combination of materials or provides an interesting prompt for inspiration.

Any teacher supply store or craft store will have a wide variety of art materials, but it can be as simple as collecting some materials from outside (such as pinecones and leaves) or pulling some items out of the recycling bin (such as toilet paper rolls, fabric scraps, and cardboard). Providing a wide variety of open-ended materials and leaving ample time for the children to use them will ensure success. The art center should also include a place to display children's

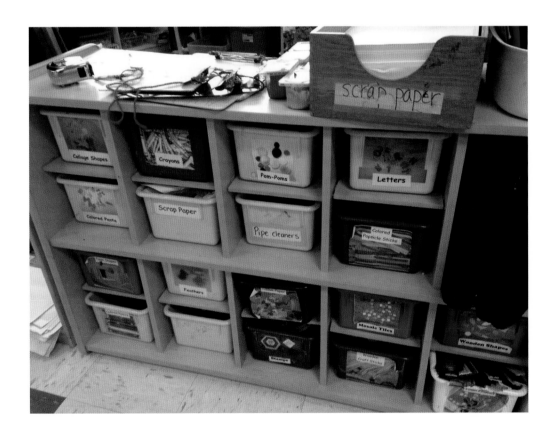

work, such as a low-hanging bulletin board for children to hang their own work on, or a shelf on which to display three-dimensional projects. Display individual artwork as if it were a masterpiece. Cover the display shelf with a piece of fabric, such as black velvet, write the name of the artist on a folded notecard, and create a beautiful display.

Some classrooms simply do not have space for a regular art center, or the area they have may need to serve multiple purposes. Even with these challenges, there are options to ensure art materials are open and accessible on a regular basis. In one program, the teachers used large bins to store supplies, which the teachers opened and set on the tables every day as soon as snack was cleaned up. A cart can also work. Think of ways to set up a cart that can be rolled out to make materials accessible during activity time. Another program placed art materials in the literacy center along with other manipulatives. Experiment with different options until you find one that works.

DIVERSITY OF MATERIALS

Your classroom and art center should highlight the diversity of your families, program, and community. Pictures and artwork displayed around the room should represent this diversity, but diversity can also be represented in the art materials you select. As you develop the art center, be sure to include materials that represent the wider population and children's experiences. This includes providing paper, crayons, and markers in a variety of colors and skin tones. Every child in the classroom should be able to select colors that are pleasing to them.

When you select collage materials, such as magazines, the children can cut up and review them to make sure the pictures are developmentally appropriate and culturally responsive and provide a wide variety of healthy images. Take some time to review what you have on hand. Do the pictures represent all cultures? Will the children in your care see pictures of people who look like them in the articles and advertisements? Do the advertisements and recipes represent food from a variety of cultures? Are there pictures of children with disabilities? Do they show the elderly in real situations that might look familiar to the children? These questions can be applied to many types of collage materials, including fabric and paper. Materials are an easy way to add diversity to your classroom. Be thoughtful as you select them for your art center.

Integrating Art and Culture into the Classroom Space

Art is everywhere. The art we choose for our home and personal space draws a picture of our culture and heritage. As teachers plan for art and develop the art center, they can integrate images of art, history, and culture throughout the classroom setting. It's easy to purchase framed prints of famous artists, and

that's a great place to start, but with some effort, teachers can find rich examples that are personally meaningful to the children and families in the program.

Every home has objects that are used to decorate the space. Often these include photographs, textiles, pottery, and artwork. A family's culture, traditions, and values are expressed through these artifacts. In one home, there may be handmade quilts or knit afghans made by a great-grandmother. In another home, there may be African artifacts purchased on a recent trip. In yet another home, artwork in the form of misshapen clay pots may hold a proud childhood memory. Some homes line the walls with pictures of family and friends, while others select pictures from a local store that create a colorful mosaic design. Such artifacts say a lot about the family that lives in the home, its history, and what the family holds dear. Take some time to look at the walls in your home. What have you selected? What do your chosen objects tell the world about you? Now reflect on the work that is displayed in your classroom. What can you add? Posters of bears, balloons, and colorful rainbows are common, but what do they say about families and cultures? Think about how you can integrate artifacts into the classroom environment that reflect the children and families in your program. Do the same in the art center.

Here are some suggestions for reflecting the diversity of children and families in the classroom environment:

- Celebrate diversity every day. Include photographs, textiles, pottery, and artwork that represent the cultures and community served by your program.

- Collect cultural artifacts for display. Examples include mosaics, African masks, Indian hand-beaded fabric, or Chinese lanterns.

- As new families join your program, continue to add art that reflects a wide variety of cultures.

Creating Lesson Plans

Teachers need planning time to think about what they would like the children to learn and to develop activities to facilitate that learning. Teachers often put curriculum into action through a topic or theme. The theme might emerge from conversations with the children, a special interest of the teacher's, the specific needs of the children, or something relevant that is happening in the community.

Tamika, the teacher in the opening vignette, is a great example of a teacher who is working very hard to ensure that all the classroom activities relate to a theme but who is getting trapped by the narrow view her planning process creates. The use of lesson plans or planning templates is a common practice in child care and preschool settings. These templates typically have rows, columns,

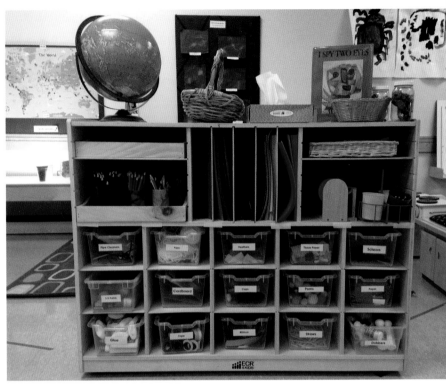

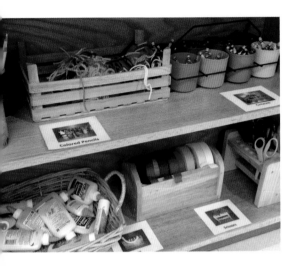

and other blank spaces where teachers indicate a theme or goal, materials needed, and activities to be added to the environment. For example, a template might include space for a teacher to list books, songs, and games for each day as well as materials that will be added to the water table, block center, dramatic play area, and art center. Materials or activities can be found to fill in every block of the template which is often posted and shared with families. Sometimes adding theme-related activities to the template can become a roadblock to open-ended art. A narrow, closed-ended view of art may emerge as teachers try to fill in the planning blocks with a specific art or craft related to the theme's topic. As discussed in the previous chapter, crafts focus on a specific skill or concept and have a predetermined outcome that is usually directed by the teacher. While it is useful for teachers to expand a theme or topic into different learning centers such as art, structured crafts bind the children to a narrow view of their project, specifically, what the teacher has cut out and prepared.

To facilitate open-ended art in a classroom, move the focus away from what can be made each day, and focus instead on new materials, techniques, and works of art. "As you work with young children, it is critical to recognize that not every creative effort will result in a product to display or exhibit" (Isbell and Yoshizawa 2016, 21). Use

the planning chart to list new or existing supplies rather than projects. For the theme, consider the different sights, sounds, and textures that relate to the topic and find ways to bring them into the classroom. Rather than browse the web for patterns, encourage the children to develop their creative side with the materials provided. The theme should inspire, not mandate, what happens for children in the art center.

THEMATIC PLANNING

Thematic planning as it pertains to art requires teachers to look deeper into a topic. It requires teachers to think about how to bring the theme into the art center; the program's curriculum model should offer some guidance. Instead of thinking about what the children can make related to the topic, teachers can ask the following questions:

- What can the children explore related to this topic?
- What do the children want to know about this topic?
- What materials can I add that relate to this topic?
- What can we hear, see, smell, taste, or touch related to this topic?

One key component of thematic planning is research. No matter what topic or theme is selected, teachers should take some time to research the topic to be sure they are using correct vocabulary, facts, and information. From there, they can brainstorm all the potential project ideas, and then think about which ones could be glued, painted, or printed. In other words, instead of reading a story about bluebirds and offering the children feathers so they can make a bluebird like the one in the story, the teacher might read the story and then pass out some feathers to let the children explore and feel them. The teacher could talk about how feathers keep the birds warm, how birds use them to line their nests, and other scientific facts. Then the teacher could explain that feathers have been added to the art center for anyone who wishes to create something with them. One child may choose to make a representation of the bluebird in the story, while another child may create a fantasy bird of paradise that they remember from a favorite movie. All the other art materials would still be available to the children, but the teacher inspires something new and leaves the children to come up with their own plan for all the feathers.

Let's return to Tamika's challenge from the introduction of this chapter. The administrator had been unimpressed by Tamika's apple-themed art projects because they were closed-ended, and she needed to think more deeply in order to provide meaningful open-ended activities related to the topic. Tamika realized she could replace the structured apple projects with real apples to inspire children by placing some on temporary display in the art center. Tamika figured

out she could also include some images of still life paintings representing apples from an online museum website. In addition, she could add a variety of red materials, such as tissue paper, paint, and construction paper, as well as other colors that represent the shading on apples, thereby presenting all the colors found on various types of apples. By adding these materials and more, Tamika could inspire the children to create art around the idea of apples, while letting the children maintain control and choice over what they complete. Now imagine Tamika's administrator's reaction to *this* theme-based plan.

Themes give educators a wonderful opportunity to weave learning centers together around a topic, but how this looks in practice may need to be reframed. Instead of finding a pattern online to use to create an object such as an apple, and then creating a sample or model from the pattern for the children to imitate, think about what you could provide as a *meaningful model*. Encourage scientific skills such as observation by placing an object in the middle of the table and asking the children to talk about what they notice. For a spring theme, a vase with fresh flowers could be set on a slice of natural wood as inspiration. A child may notice the unusual colors of the flowers, or the way one side of the wood is smooth while the other is ridged. Then help the children find ways to represent what they see artistically. Rather than copying a pattern, they are observing and talking about what they notice.

Personal Reflection and Practice

Prepare: Using the five categories of art defined in this chapter—drawing materials, paints, three-dimensional materials, collage materials, and tools—list all the items in your current art center, sorted by category.

Act: Now visit a local teacher supply store or website. Browse around and look for the items that would fill out your list and provide a balance of materials. Look around your classroom and the building. What else can you find? What could you ask families to contribute?

Reflect: Is there a specific art category that is lacking in your classroom? What can you add or do to the center tomorrow to offer a richer experience for the children?

Learning Outcomes: They're Not Artists; Do I Need a Plan?

Justin offers art projects to the children in his classroom on a daily basis. Justin prefers structured art because he thinks it will help the children learn how to follow directions and he can make sure that everyone has completed the project. His administrator has encouraged him to think about offering more open-ended art opportunities and to be able to explain to the parents what children are learning. Justin wonders, "They're learning how to make all kinds of things and follow directions. Isn't that the point?"

Like Justin, some teachers wonder whether they need to plan for open-ended art for it to occur. Some teachers may think that if they have an art center, then they've made open-ended art opportunities available and they plan for activities that focus on producing a product, because coming up with ideas to highlight the theme is easy. During a spring theme, Justin may decide to leave a few pastel colors at the easel, then cut each child's painting into the shape of a flower that can be hung from the ceiling. While the painted flowers may look festive and decorate the room, what did the children learn from the activity? This chapter focuses on how to turn the ideas that emerge from curriculum and planning into open-ended art activities based on learning outcomes.

Finding Your Purpose: Creating Learning Outcomes

Once a teacher has developed some ideas about a topic or theme and decided what the children will explore in the art center, it's time to develop some specific learning outcomes, apply them to the art activities, and follow up with feedback and a final assessment. Learning outcomes can be developed for any teaching or learning situation, from early childhood through adulthood. They define the purpose behind the activity, materials, or tools. Whether teachers are expected to follow NAEYC Accreditation standards, Common Core State Standards, Early Learning Guidelines, state licensing regulations, Head Start Program Performance Standards, or a combination of these, outcomes can be written

and adjusted based on the children in the group. Fortunately, many of the state or program documents listed above have standards, or indicators, already written in the form of measurable outcomes. As an example, the *New York State Prekindergarten Foundation for the Common Core* identifies two standards, called benchmarks in New York, for the category of visual arts: "Expresses oneself and represents what he/she knows, thinks, believes, and feels through visual arts" and "Responds and react to visual arts created by themselves and others" (New York State Department of Education 2011, 34).

Teachers oftentimes plan an activity or experience and then look to see what standards or guidelines it covers. Others may look at standards first and then formulate what they want to *teach* the children. Instead, start with the standards and consider what the children are expected to *learn* based on these standards. Then begin to formulate activities with specific outcomes in mind.

Learning outcomes are purposeful statements of what children should understand or be able to do at the end of an activity or lesson. Outcome statements set the expectations for the measurable learning that is intended to take place as a result of instruction. These statements include an action (in the form of a verb) and an impact (or what children will do or be able to do). A well-written outcome will show the children acting on the material, either mentally or physically, and connecting the material to something else, such as an experience, content, or prior knowledge:

> As a result of this activity, the children will express their ideas about a piece of artwork.

> As a result of this activity, children will predict what happens when primary colors are mixed.

Look carefully at the verbs *express* and *predict* in the examples above. They are statements of the expected effects of the instruction expressed in terms of skill or demonstration; they are not merely statements of activities. They describe the expectation of what the children will be able to think or do as a result of the instruction or activity. Action verbs are important because they indicate what the children should be able to demonstrate and can be measured in some manner. The following are *not* learning outcomes:

> The children will make a rabbit using cotton balls.

> The children will do marble painting with the help of the teacher.

These activities might explain what the teacher wants the children to make in the art center, but the statements do not describe what the children will be able to do as a result of the activity. Stating outcomes for learning allows teachers and children to focus on what is important in the art experience. In addition, it helps the teacher clearly identify the type of instruction, materials, and facilitation needed to achieve the stated outcome and to evaluate the success of the instruction.

Applying Outcome to Art Activities

Active learning defines a classroom where children are directly involved in the learning process. Activities allow for active learning that may transpire in a small group, in pairs, or individually within learning centers. In daily activities, including art, children can be observed based on specific learning outcomes. Leave out a wide variety of brushes and observe how the children use them. Teach the children how to make polka dots, swirls, and crisscross patterns with the different brushes and then step away and observe how the children respond. Teachers know that learners will learn more in proportion to how engaged they are with what they are trying to learn. Give children some meaningful tasks and observe what they choose to create.

Children are further encouraged to develop an interest in the artistic expression of others when interest in their work is modeled for them. When teachers ask children questions as they work, children feel encouraged to ask questions of each other. Observe, take notes, and document their growing abilities as they relate to the outcomes. Teachers must be eager learners and willing to share in the process of learning with the children in their class or program.

How do we teach children to appreciate art or represent what they know, think, believe, and feel through visual arts? The right activity can highlight the artists' process and intention while deepening the viewers' understanding of their work. For people who have not studied art, this may seem like a daunting task, but a good activity is not that difficult. It should relate clearly to the overall theme, goal, or outcome.

Learning is more meaningful when it is based on personal observations and experiences. That cotton ball rabbit may look cute and fit right into a teacher's theme, but what does it really teach children about art or rabbits? What is the learning outcome? Is it related to the exploration of art materials? If so, cotton balls may be a good start, but the rabbit art may not be the best option. Is the outcome related to scientific principles, such as observing the parts of the rabbit? If so, perhaps the teacher could bring a rabbit into the classroom to let children touch and feel its fur, and then ask them to represent that experience in some way with art materials. The same type of activity can be represented in many different ways for a richer experience. Let the specific outcomes you hope to achieve drive the activity.

New Definitions

When we revisit the continuum of open- and closed-ended art activities within the context of outcomes, we can determine what level of structure is appropriate by carefully evaluating the purpose of the activity. Children benefit from

opportunities to explore and create with a wide variety of art media, but adding in some structured elements may be appropriate to meet specific learning outcomes. Structured activities designed to meet specific learning outcomes should, however, be defined by the content they cover, such as an activity focused on science, math, or literacy. For example, a classroom teacher may develop a literature theme that emphasizes several books by author Mo Willems. It would be perfectly appropriate for the teacher to plan an activity based on the book series, provided it serves a purpose. Paper bags and crayons could be supplied to the children to make puppets of the characters Pigeon, Piggie, and Elephant Gerald. The purpose of the activity would be to emphasize language development, and the children could use their puppets to reenact the story. The activity would be a literacy activity with a specific outcome related to language and literacy—not an art activity. Even so, even non-art activities can provide opportunities for the children to be creative. The children could be encouraged to make their puppets in any manner they choose from materials in the art center, or they could add in another character to the storyline.

Following Directions

At the beginning of the chapter, Justin explained that he prefers structured art because he thinks it will help the children learn how to follow directions and because he can make sure that everyone completes the project of the day. Unfortunately, these structured group art activities often leave him feeling frustrated as he runs around the table trying to serve multiple children.

Some teachers, like Justin, report using structured activities to help children learn how to follow directions. But for a number of reasons, it's not reasonable to expect young children to work on something (such as an art activity) as a large group. First, all children are in different places developmentally so it's not helpful to require them to complete the same activities at the same time in this manner. Second, if a child needs additional scaffolding, such as the child who needs the teacher to hold the paper while she makes her first snips with a scissors, the teacher won't be able to help more than one or two children in the group. In addition, when the teacher is helping one child, how can the rest be observed and supported?

There are better opportunities for children to learn how to follow directions. To start, the typical early childhood environment provides a wide variety of opportunities throughout the day for structured learning and self-correcting materials such as puzzles, board games, or science experiments. Even cooking activities provide an opportunity for children to follow specific instructions. The key to developmentally appropriate art experiences is connecting the curriculum, the instruction, the experience, and, finally, the assessment of the activity. Children will learn to follow one-step and two-step instructions as they grow and develop, but it's probably not something they need to be taught as part of an art activity. The children may appear to enjoy their work as they create the penguin or flower design step-by-step in a group, but how do educators know it's a good use of their time together in the classroom? What about the child who refuses to participate in the structured activity, or who rushes through the activity out of boredom? Following directions may be an important developmental skill, but it does not need to be taught or assessed as part of an art activity. Think about it as a side effect of good curriculum. If the room offers good experiences, then children will develop the ability to follow directions. Justin should use the art area to encourage outcomes that support children's creativity and find other ways to reinforce skills such as following directions.

TASK ANALYSIS

When children have difficulty remembering the steps they need to follow to accomplish something, teachers can do a task analysis. Task analysis requires teachers to observe a process and then break the process into steps, for example, painting at

the easel. Depending on the setting and where materials are kept, painting at the easel may involve several steps, including getting and putting on a smock, clipping paper on the easel, and putting the brush back in the correct paint pot while painting. When the child is done, there may be additional steps, such as washing the brushes or putting the painting on a drying rack. Each of these steps, or tasks, needs to be taught through modeling, practicing, and reminding. One way to gradually support children's independence is to create visual directions using pictures to illustrate each part of a process. Visual directions could be posted at certain places in the room, such as the easel, or a teacher could create an "art-making direction book." Depending on the age and ability of the children, the instructions could be entirely pictures or a combination of pictures and words.

Evaluation

Let's pretend that you took an afternoon cooking class. For four hours, you learned how to chop, dice, sauté, and grill. Now it's time to impress your family and guests. You pull out a new recipe and attempt to follow it exactly, but the instructions prove more complicated than anticipated and the final product is pretty terrible. How do you feel? What will you do? Will you decide the dish is good enough to serve and hope for the best, or will you throw it away and order a pizza? What will you learn from the experience?

Everyone, even very young children, has the ability to evaluate or appraise their own work. As young children begin to create an art project, they may not know exactly what they are going to produce. Depending on their age, they form a plan in their mind as they begin to work. Lines become swirls and swirls become a storm of colors. When they run out of space or material, they step back and admire their work. Did the colors mix the way they intended? Did they get an interesting effect? Without words, they are evaluating the finished project. Let them appreciate their effort on their own. Teachers don't need to offer praise, such as "Good job!" or "Looks great!" The children already know if it is good enough to hang up or should be discarded.

When children are not satisfied with the final product, they may throw it away and start a new one, or they may leave the art center altogether. That's okay! The ability to evaluate one's own work is an important developmental skill. They may love the project and ask you to hang it in a place of respect, such as the refrigerator, or they may throw it away themselves. Children know the difference between a final project that turns out great, and something that does not turn out as expected. Let them decide if it's good enough to share. Are they proud of it and want to hang it up, or leave it behind? When children have an opportunity to attempt something new, they may fail, but ultimately, they will grow into very competent adults.

Assessing the Activities

Many teachers plan the same activities from one year to the next. This could be a time-saver, but if the curriculum is too rigid, then there is no room to assess, reflect, and adjust. As a result, the group may seem to be overwhelmed and confused one year, while the next year the group may seem bored or unchallenged. Let's follow Sandra as she puts the assessment process in motion for us.

Sandra developed a thematic unit around the topic of color that kicks off her programs' curriculum each year. On Wednesday, she decided to emphasize the following outcome: *As a result of this activity, the children will be able to predict what happens when primary colors are mixed.* Sandra began the day by reading *White Rabbit's Colors* by Alan Baker during group time. As a group, she and the children talked about the book and made predictions about mixing colors. During learning center activities, Sandra placed the primary paint colors red, blue, and yellow at the easel. As the children moved around the room, she used an attendance sheet to make a note of who painted at the easel. Sandra asked some of the children questions about what they noticed as they painted, or she asked them to make a prediction about what would happen to the colors. She made notes on the attendance sheet to be recorded later in the children's portfolios. As she moved around the classroom throughout the morning to support learning in other centers, Sandra kept an eye on the easel and continued to mark down which children had an accurate prediction. At the end of the day, Sandra was happy to report that sixteen out of twenty-two children could accurately report what would happen to the colors, while only two could not and four chose not to paint that day. For most of the children, she could determine that her outcome had been met, but she had a list of those children who still needed to be assessed and who needed a little extra support. As Sandra reflected on the day, she decided to read some additional books about color mixing and to leave the primary colors at the easel for another week or two, until the remaining children had successfully met the outcome. She would continue to revisit the outcome with the remaining children. At the same time, she knew that she could move on to more challenging skills with most of the children.

Let's revisit one of our previous outcomes that didn't seem to fit: *The children will make a rabbit using cotton balls.* How would you assess this outcome? Would you rate the children based on how good their rabbit looks? Would you evaluate whether the eyes were placed in the correct place? It just doesn't seem to fit. And if the teacher cut out the shapes or assisted the child in some way—would that be considered cheating?

With young children, teachers need to remember that outcomes should remain fluid. Some children may not be developmentally ready to comprehend the lesson being taught. They may need more time with the materials, or a little

more support before the lesson makes sense to them. Professional assessment tools generally allow a range of descriptors, such as *met, not met,* or *emerging.* Assessment should be used to gather information about each child as more activities are planned.

Do teachers need to make sure that everyone completes the same activity at the same time so they can be measured? Absolutely not! Developing a system for ongoing assessment does not require teachers to ask every child the same questions or expect them to finish the same things at the same time. Rather, it requires teachers to get to know each child where they are and plan activities based on their needs. If the easel remains open and accessible every day, different children could be asked questions every day. One teacher might plan to spend a week or even a month around the topic of mixing colors only to discover that most of the children already know that red and yellow can be mixed together to make orange. Assessing the children helps teachers ensure that their practice reflects the real needs of the children.

Providing Feedback

While evaluation and assessment are important, there are many times when children do not need to be assessed. Instead they can simply create while teachers observe and offer encouragement or feedback. How do teachers nurture artistic skills in children? They offer a wide variety of experiences based on the age and ability of the children, and then they respond to the children's efforts and offer genuine feedback in appropriate ways.

As the children begin to use the art materials independently to make lines and shapes, it's important to allow them to process the feelings that come with accomplishment, rather than to take that opportunity away from them with some simple judgement, such as "Good job!" Phrases such as "Good job" or "Nice work" offer praise. Praise suggests approval or admiration; it doesn't provide the child with any information. While the praise is well-meaning, it places the emphasis on the adult rather than the child. From the time they are very young, children feel a sense of pride, such as the pride felt by a child who zippers up his coat for the first time. The feeling of pride is intrinsic and comes from the knowledge that the child did it himself. At the same time, children know when their work is not exactly what they had hoped. They will report that it's not very good and they will happily throw it away to try again. When adults interfere or tell a child her project is great when the child herself is not proud of it, the messages get mixed. Imagine you try a new recipe for dinner that doesn't turn out very well. You know it's bland and tasteless, and your friend knows it's bland and tasteless. What would you expect her to say? Rather than false praise, how about, "Thank you for inviting me dinner. It's so good to spend time with you!"

Feedback provides information or helps an individual with her evaluation of the work. Feedback is helpful when children begin to struggle or appear to have difficulty with a task, but it's important ask first. A teacher could say, "It looks like you're having trouble with the glue. Is there anything I can do to help?"

For infants or young toddlers, statements tend to be most effective. You might offer, "Look at all the blue!" As they grasp the language, their desire to talk about their work grows. You might use questions or statements to ask children about their artwork and provide feedback including:

- Tell me about this picture.
- How do you feel about this picture?
- What was your plan?
- What will you do next?
- How did you make this pattern (line, shape)?
- What is happening here?
- This part is interesting.

Teachers need to remember that infants, toddlers, and some preschoolers are engaging in the experience of art rather than planning to produce art. For infants and toddlers, teachers can complete observations rather than ask questions. This provides language for nonverbal infants or toddlers who are beginning to speak. A teacher may say, "You pushed the crayon on your paper. Look, it made marks." As you provide feedback to children through questions or offers of assistance, don't assume the child has a specific plan.

Classroom or Program Assessment

While it's important to assess the success of individual classroom activities, teachers can also assess the classroom and overall program for quality. Developmentally appropriate practice as defined by NAEYC serves as the foundation for best practices in early childhood programs. "Grounded both in the research on child development and learning and in the knowledge base regarding educational effectiveness, the framework outlines practice that promotes young children's optimal learning and development" (Copple and Bredekamp 2009, 1). NAEYC's guidelines serve as the foundation for all programs that serve children from birth through age eight.

In terms of art, Copple and Bredekamp (2009, 245) offer, "Rather than showing the children what to make, teachers make a wide variety of art media available for children to explore and work with and demonstrate new techniques or uses of materials to expand what children can do with them." Making art available is achieved through the development of the art center and may include a wide variety of collage materials, pastels, watercolors, paints and easels, scrap paper in a variety of sizes and textures, clay, natural materials, and glue (just to name a few). Developmentally appropriate practice, as it relates to art and aesthetic development is widely accepted in state standards and the guidelines of national organizations (for example, Kansas State Education Department 2011; National Coalition for Core Art Standards 2012; New York State Department of Education 2011).

Practical aspects of developmentally appropriate practice can be assessed in a classroom using an environment rating scale (ERS). The ERS tools are nationally recognized observational assessment tools. There are four ERS tools, each designed for a different segment of the early childhood field. They include the *Early Childhood Environment Rating Scale* (ECERS-3) (Harms, Clifford, and Cryer 2014), the *Infant/Toddler Environment Rating Scale* (ITERS-3) (Harms et al. 2017), the *School-Age Care Environment Rating Scale* (SACERS) (Harms, Jacobs, and White 2013), and the *Family Child Care Environment Rating Scale* (FCCERS-R) (Harms, Cryer, and Clifford 2007). Each one of these tools includes competencies that are important in an assessment of the program, with indicators that are specific to the age of the children. As an example, the ECERS-3 is designed for preschool environments. The tool allows professionals to observe and assess a classroom based on a scale of one to seven in thirty-five specific competency areas, with art listed as one of the specific areas (Harms et al. 2014). The ITERS-3 is designed for a classroom that serves children from birth to about thirty-six months (Harms, et al. 2017). These scales are typically used to assess overall classroom quality, but close examination of the competencies related to art can help practitioners determine if they are on the right path.

States often use the ERS, or some other classroom observation tool, as part of their Quality Rating and Improvement Systems. Currently thirty-eight states have QRIS in place (QRIS National Learning Network, accessed 2017). We'll take a closer look at these tools in future chapters.

Personal Reflection and Practice

Now it's time to practice writing learning outcomes for your group of children.

Prepare: Find the learning standards or guidelines that are followed by your program or school. Look at the standards, indicators, or guidelines that are listed under art and perhaps fine motor. List the verbs used in these statements. What type of words do you find? Do they describe action or listening activities?

Act: Using these standards or guidelines and one of the action verbs you found, develop one outcome that is appropriate for the children in your classroom.

Reflect: Think about the type of activity that could be used to teach and then measure this learning. Does this differ from the type of learning you currently employ? Think about how you might change your practice to use learning outcomes on a daily basis. Based on your reflection, think about what steps you could follow to change your practice.

Getting Families on Board: Why Aren't You Sending Home Any Work?

During parent conferences, one mother presses Aya, the head teacher, on the topic of art. The mother asks, "Why don't you send things home every day? My friends have pictures all over the fridge, and Aaron hasn't produced a picture in weeks." Aya knows that Aaron is a busy little boy, and as much as Aya encourages Aaron to try something new in the art center, he prefers the block area, where he has been working on towers and ramps with a couple of friends. Aya knows that her program administrator doesn't like to see a structured art time, but in response to the repeated questions from parents, she considers scheduling a project before lunch every day.

Teachers report that families can create barriers related to art in the classroom. One parent may complain about the stains she finds on her daughter's clothing, while another questions why her son isn't doing any art at all. Some families like to see an art project come home every day, and they seem pleased when they can easily recognize what was made. Some teachers may respond by planning an art activity that can be sent home every day, while others may change the type of work that is sent home based on what they think the parents expect to see. Both approaches are counterproductive to the creative process that should be encouraged in young children. This chapter explores the barriers created by parents and shares a number of solutions, including how to integrate different perspectives and cultures into classroom displays of art.

Families, Children, and Crafts

Some families feel good when they see the crafts that have been completed when they pick up their children at the end of the day. When a parent sees a giraffe or flower in their child's locker or cubby, it's clear to the parent what the children did during the day. While it is true that families like to know the classroom theme or art project of the day, that doesn't mean that we need to change what we know is right for the children.

As discussed in previous chapters, when a teacher selects the project and cuts out the pieces and provides a model, there is very little effort required on behalf of the child. They have lost the opportunity to create a project that would result in the sense of accomplishment that comes from hard work as they run their hands through the materials and glue the collage items in just the right place.

It is true that families will ask questions about the work they see coming home—and they should! That does not mean, however, that the curriculum and activities need to be adjusted based on their questions. It means that the program as a whole needs to understand why the questions are being asked and respond in a productive way. Developmentally appropriate practice suggests that teachers and families make decisions together regarding learning goals and approaches to learning (Copple and Bredekamp 2009). While it's important to understand families' perspectives regarding the creative art projects that are sent home, it's equally important to help families understand the developmental need for children to explore materials and develop their individual artistic talents. Some children may spend a lot of time in the art center, and others may spend very little time. While teachers can help facilitate the work of all children in the art area, they can't realistically expect every child to make a project every day. Remind families that a lot of active learning occurs throughout the day, and not every child can participate in every activity. If teachers' focus is primarily on what is being sent home, then the children will miss opportunities to explore all the other learning centers on a daily basis.

Potential Barriers

When families raise questions about art, barriers may persist if teachers do not understand the artistic process or know how to effectively explain it. How do the professionals in a classroom or program respond when someone asks questions about the art that comes home because it "doesn't look like anything?" High-quality programs place an emphasis on two-way communication with families. This means that teachers do not just explain why they do something one way or another, but they take the time to explore a family's concern when the question is raised. Teachers should use these opportunities to listen to families' questions and concerns. When someone asks why nothing is coming home, they may really be asking a different question. Table 4.1 provides some examples of common questions asked by families, and what they may really be asking.

TABLE 4.1. What Parents Mean

WHAT PARENTS ASK	WHAT THEY REALLY MEAN
Why is nothing coming home?	What does my child do all day?
Why does he scribble?	Is my child normal?
What did you make today?	What is the point of this activity?

Families should be encouraged to ask these questions. Understand their issues and concerns, follow up by reinforcing what the children are learning, and share notes about the learning that occurs spontaneously in learning centers, including art. Some programs may find it helpful to hold a seminar on the topic of art, or to include some discussion in the parent handbook or at orientation to help families understand the fundamental reasons why open-ended art is so powerful. Communicate the value of creative art to parents on an ongoing basis.

Documenting the children's process along with the product will provide continued opportunities to explain what children are learning as they create. Taking the time to write an explanation of the art activity or to dictate the story for children on the back of a picture translates the experience for parents. Describing what happens in the art center through the materials and activities, and how these relate to children's development and the program or state standards, also translates the learning. Consider providing a link to the standards, or use the standards language in your explanations. Including brief explanations on bulletin boards or other displays will help families understand the development and learning that occurs as children "scribble" or "just paint." The following provides

suggestions on ways to display children's individual artwork for both other children and families to view and appreciate:

- Frame children's artwork. Take the time to purchase some real picture frames and rotate the art that is hung on the wall in the classroom or hallway.

- Take pictures of children using art materials throughout the day and display them in a digital frame or on a bulletin board.

- Let children choose the projects they wish to display and draw attention to them as families visit the classroom.

- Develop a portfolio. Collect samples of artwork for each child throughout the year. When parents ask questions about the work coming home, share the folder and talk about the developmental growth that has been observed.

- Provide posters that promote art and that explain the purpose behind the artwork on display.

- Display artwork as if your classroom were an art gallery or museum. Frame pictures, label three-dimensional work, and set up displays that include descriptions of materials, artists and dates to show respect for the work that is completed.

Another barrier that is reported by teachers is related to the fancy or expensive clothing that some children wear. Parents send their children to school in new clothing, only to get upset when it is soiled during the course of play

activities. Little Ashley, who seemed to attract a mess wherever she went, is the perfect example. Day after day her mother sent her to school in beautiful new clothing, and no matter what the teachers tried, Ashley would get paint on her cuffs or mud on her knees. Finally, her teachers dressed her in a special smock that had tight sleeves right down to her wrists, and they sent her to paint at the easel completely covered up to her neck. As Ashley began to paint, she looked down at the paint cups to stir and mix the paint, touching her head to the wet paint that had just been applied to the paper on the easel. Her clothes were clean, but she went home with blue hair. The following day the teachers added a plastic hair cap to the required gear, but Ashley splattered the paint by mistake and it dotted across her face. No matter what the teachers tried, Ashley would find a way to get messy. She was a toddler with a wonderful eye for fun and color. Her mother simply had to expect that she was going to get messy.

Many hours were spent by the teachers planning, preparing, and discussing this issue for one little girl who was destined to paint with the enthusiasm of the abstract painter Jackson Pollock. In Ashley's situation, the mother had been raised in an environment where it was very important for children to be dressed, neat, and clean at all times. Mom had never worn play clothes and didn't understand why her daughter needed to get messy. It took a lot of time to negotiate a compromise, but the teachers finally convinced Ashley's mother to send her to preschool in some of the "new" outfits that had been stained on the first few days of school, and Ashley could change clothes at the end of the day if they were going to run errands on the way home.

When parents seem to be creating a barrier to open-ended and messy artwork, do a little research to determine the concern. Begin with conversations that help understand the parents' perspective, and work to help them understand good early childhood teaching practices. There are ways that barriers can be avoided through communication. Here are some suggestions for practice:

- During the first meeting with families, explain the philosophy of open-ended art and share examples. Share pictures of the children involved in messy projects, so the expectations are very clear right from the beginning.

- Be thoughtful of the mess. Smocks should always be available, and they should be enforced for particularly messy projects. Encourage parents to send children in work clothes, and be sure to have a change of clothes available for accidents such as wet sleeves.

- Use washable materials. This is a *must* unless the situation is very controlled, but please note that art materials may stain, even when they claim to be washable.

- Set specific days for very messy projects. Give parents an opportunity to plan and prepare for something that may be extra messy, such as a project where the children walk through paint and across paper. Could these experiences always happen on certain days and times, so the parents know to dress the children in old clothes on the same day each week?

- Explore how cultural differences may affect expectations set by families. Are there specific groups of families that tend to avoid mess? If so, explore these differences and find ways to include and compromise.

Personal Reflection and Practice

Prepare: During a meeting or training session, divide into small groups to brainstorm some of the potential questions that parents might ask regarding creative art.

Act: Develop a list of possible responses based on the curriculum model followed by the program. Be sure to include responses based on good child development. Divide the group into pairs. One person should ask questions from the list developed by the group, the others should practice professional responses.

Reflect: Do you feel prepared to respond to questions about open-ended art? Is there anything you would like to know that might help you feel more confident when speaking with families?

PART 2

Art and Child Development

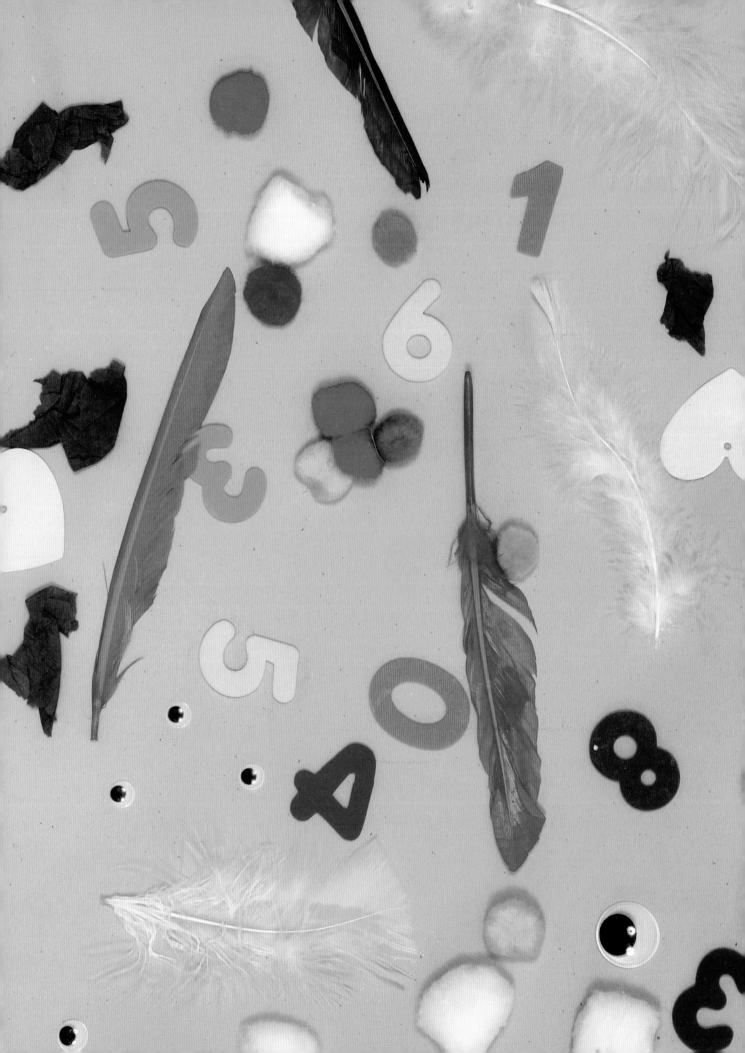

Infants: How Can I Find Time for Art in the Infant Classroom?

Sammy spends all day moving through caregiving routines. If there is a slow point during the morning or afternoon (which rarely happens), she uses it to clean the room and prepare for diapering or the next meal. She wonders, "How can I find time for art?"

The infant classroom is consumed by important caregiving routines, and there are many barriers that may prevent teachers from providing opportunities for art. While the care of very young infants emphasizes hugging and rocking, as children become mobile and gain independence, the opportunities for art (although still somewhat limited) begin to expand. After all, during the first three years of life, children develop faster than during any other period of their lives (Copple et al. 2013). This chapter highlights typical development of infants and explores ways to integrate art in appropriate ways.

What Is Happening Developmentally

Infancy is a period of rapid gross- and fine-motor development. Young infants, from birth to approximately eight months, are learning to feel safe in their surroundings. Feeding and comforting babies are a primary focus of early care. Children of this age are discovering their body parts, and as their muscles develop, they begin to gain control over how these body parts work. Between four and eight months, most infants develop the ability to pick up objects and begin to use their pincer grip to grasp an item between their fingertip and thumb. As infants become mobile, they begin to develop awareness and strengthen the fine-motor muscles that allow them to hold writing materials, such as crayons.

Mobile infants spend a good portion of their day using their muscles as they explore their surroundings and the objects in the environment. This involves pushing, pulling, dropping, banging, holding, and engaging with objects in various ways. Teachers know how to create an environment that includes objects and opportunities that encourage mobile infants' exploration, but many teachers are

puzzled by art. Child care providers often ask questions reflecting this confusion: Do babies need to do art? Babies are messy and put everything in their mouths; how can I do art with them?

Sensory Explorations: Infant "Art"

Art with infants is not about creating specific items. Art with infants is about sensory exploration. The theorist Jean Piaget proposed that children in this stage of development make sense of their world through their motor and sensory experiences. They learn by touching, smelling, hearing, tasting, and seeing. Sensory experiences provide stimuli for development, which is why infants put objects in their mouths and touch, push, and interact with objects. Piaget identified this as the sensorimotor stage of cognitive development. As infants touch and manipulate items of various textures, they begin to develop classifications of objects. Piaget referred to these classifications as schemas. Schemas are the mental images that people develop. For example, infants have a schema for food based on how they are fed. A child who is breastfed has a different schema than a slightly older child who is beginning to learn to drink from a sippy cup and feed himself.

Sensory experiences help infants develop and update their schemas. An infant begins to develop an understanding of "ball" by playing with a smooth, round, rubber object. While playing with the object, the infant squeezes it and feels its surface. The infant pushes it and discovers that the object rolls. A teacher sitting with the infant talks about the object. "You found a ball. I see that you pushed it. Can you crawl to the ball?" The child begins to develop a schema for "ball" based on touching and interacting with a ball. Introducing another ball with a different texture or color, or with multiple textures or colors, or that emits a sound when bounced or rolled, and hearing the new ball repeatedly named helps the child's schema become more precise. This new ball allows the child to picture various mental images when an adult says, "Do you want to play with the ball?" This type of sensory experience helps young children develop their schemas, expanding the children's mental images and their understanding of an object's functions or characteristics. Developing and strengthening schemas build a foundation for future word production, vocabulary, and other early literacy understandings.

Young infants are also beginning to develop an understanding of cause and effect. For example, a scarf tucked into an empty tissue box may invite an infant to pull on the scarf. Pulling the part of the scarf that is visible may produce more of the scarf, enough to cover a toy, or even the baby herself! The understanding of cause and effect continues to evolve as mobile infants develop their small muscles and begin to use art materials. Grasping a crayon and pushing it onto

paper will eventually cause a mark to appear on the paper. As the older infant continues to bang and otherwise experiment with the crayon, he begins to realize that banging or pushing the crayon is causing the mark.

Sensory experiences that are appropriate for young infants always take safety into consideration first. Make sure materials are nontoxic, washable, and free from being a choking hazard. Shaving cream and slime made from borax may be popular for sensory exploration, but they are not safe for use with infants. Materials that can break, such as crayons, need to be inspected regularly to ensure there are no pieces small enough to be choked on. Although glitter is a fun material, it is also not recommended for infants; it contains tiny, sharp particles that can get into babies' eyes. Safe art materials for infants include unbroken crayons and chalk.

Once safety issues have been addressed, consider textures that can be introduced to infants. A variety of textured fabrics, such a flannel, tulle, denim, and corduroy fabrics, is one way to provide sensory experiences. Infants can explore textured fabric balls or pieces of textured fabric. Textured nontoxic papers, such as butcher paper, rice paper, tissue paper, waxed paper, and corrugated cardboard, can be offered for crumpling, tearing, and touching. Fabric and textured paper can also be attached to a surface such as a length of craft paper to create a surface for exploring. For example, a collection of papers or fabrics can create a mat that an infant can sit on, crawl over, or touch. Various panels of fabric can also be attached to a closed box to encourage exploration.

Sensory experiences can be a way of introducing families' cultures into the infant classroom environment. Choosing materials that reflect the cultures of the children's families demonstrates respect for and awareness of cultures. There may be fabric from a certain country or area that has a unique pattern or texture. Babies are not learning to identify or name colors but through the environment they are exposed to colors and fabrics which introduces colors or designs. Many cultures reproduce common cultural designs in fabrics. Often there are special processes used to create the cloths, such as batik or silk woven with metallic designs. Families are often pleased to share cloth or clothing. If an item is not baby friendly, for instance, silk that is not easily washed, the item could be displayed as decoration. Other examples of materials that reflect family cultures could be items made of wood, such as bowls or large spoons, or containers, such as baskets.

The Idea of "Pre-Art"

Teachers provide young children with books they can't read; sometimes the child will look at a book that is both upside down and backward. Providing opportunities to engage and interact with books and other forms of literacy is recognized

as important to the development of a foundation for reading or reading readiness. Teachers similarly engage young children with materials, experiences, and language related to mathematics or science before children are cognitively ready to engage in counting or science experiments. Teachers do these things because research tells them that infants begin to learn through sensory experiences, manipulating objects, and hearing language.

Pre-art is that early process when infants engage in sensory experiences, ripping and crumpling paper and making marks on paper. Pre-art is the sensory and motor experiences that infants (and young toddlers) engage in as they develop ways to manipulate materials in forms of self-expression and exploration. It is through early opportunities that they accumulate experiences using their senses to learn about objects, begin to classify objects, and start to develop an understanding of cause and effect.

Is Art Worth the Effort?

Art during infancy is about children exploring materials and beginning to develop autonomy in making decisions. Frequently teachers report feeling pressure to have infants "do art" when the goal should be to create sensory experiences for infants and, as they get older, to begin to introduce the exploration of art materials. Let's visit two infant classrooms as they prepare special gifts for Mother's Day.

In one classroom, a teacher proudly displayed paper flowers that the infants, aged eight to twelve months old, created for Mother's Day. During the previous week, the teacher had painted each baby's hands and pressed them on white paper to make handprints. The teacher did this on a couple of occasions over the course of several days, so she could complete the projects with all the children using two different colors of paint. The project took many steps. Each baby's hand had to be cleaned before the teacher could paint the next baby's hand. The teacher also had to cut around each handprint, attach a pipe cleaner stem, wrap the handprint flower cutouts in tissue, and write "I love you, Mommy" on a note "signed" by the baby. This teacher spent a lot of time preparing the materials, cleaning the babies, and finishing the project.

Contrast this with a Mother's Day project created in another infant class-room. The teacher in this classroom placed textured fabric balls on the floor near the babies. As the babies played with the balls, or as the youngest infants watched, he took a picture of each child. Mothers with an infant in this class-room received pictures in inexpensive frames with a card that described what the baby was doing as a Mother's Day token. Mothers in both settings were touched by the gifts, but the teacher in the first scenario spent far more time and energy on the project.

You can imagine the first teacher declaring, "Art with babies is too much work." Many teachers would agree; product projects with infants and young children are hard work. They take a lot of planning, time, and energy to create a multistep product, gathering materials, completing each step with wiggly children who have short attention spans, cleaning up after each step, and, if needed, putting parts together. Most of the time, the children aren't interested in the materials or the products being created. Yet teachers are told art is important. Art is important, but early childhood teachers need to reevaluate what they consider art with infants to be.

Let's return to the classroom scenario with the teacher who made the Mother's Day bouquets. This teacher worked very hard to create a sensory experience for the infants and to create a beautiful memento for the mothers. But who did most of the work? The teacher! An old saying reminds us, "Whoever does the most work does the most learning." In the bouquet-making scenario, the teacher did the most work, and the product resulting from a closed-ended activity is what was emphasized. The children may have learned something while the paint was on their hands, but not in the same way a child does when she chooses to engage in a sensory experience. Early childhood learning guidelines from individual states, Head Start, and programs for infants often focus on infants engaging in creative arts to express themselves. Think about whether the infants were expressing themselves in the Mother's Day bouquet example.

How Do I Introduce Art?

The *Infant/Toddler Environment Rating Scale*, or ITERS-3, is a nationally recognized rating scale designed to assess infant and toddler group settings so teachers can improve the overall quality of the environment. When rating the environment, the person responsible for scoring the program (typically a trained administrator or assessor) observes the overall classroom program; for this book's purposes, the focus will be only on art. The rating scale does not require art experiences for children younger than twelve months (Harms et al. 2017). The researchers suggest that when all children in a group are younger than twelve months, other learning experiences are more appropriate than using art materials. Very young infants should have pre-art, sensory-based experiences rather than direct experiences with art materials. Think of using fabrics, papers, and natural elements, such as feathers or pinecones. Infants can explore textures, shapes, and colors as they touch, see, smell, and handle the objects. Infants as young as four months can recognize faces and distinguish the difference between light and dark shades, which is why many commercial infant toys show black-and-white contrast.

Teachers can create experiences that provide infants varying ways of interacting with sensory materials. Using the *Head Start Early Learning Outcomes Framework*, a teacher, Itunu, may plan sensory experiences to meet the *"explores properties of objects and materials by using various hand actions, such as pulling at them, picking them up to examine"* indicator for an eight- to eighteen-month-old child (Office of Head Start 2015, 70). Her learning outcome would be the following: *Children will explore properties of materials by using hand actions to examine them.* This teacher may use a tissue box or a commercial hide-and-seek product to hide scarves or pieces of textured fabric. From a sitting or crawling position, the child can pull the fabric from the box, each piece providing a different sensory experience. Textured balls, soft shapes, and other items that can be made or purchased can also be used. Depending on a child's age, the teacher can hold or position natural materials, such as feathers, pinecones, or rocks, for babies to touch. It's that easy. While teachers may choose to create a craft such as handprint flowers with infants, the infants are not actually making art.

As children gain muscle strength and mobility, around eight months old, they can be introduced to art materials. As they use the material, the children develop and use fine-motor muscles. Marking paper with an art material becomes an experiment or investigation. While the marks may not be deliberate or even art-like, the children begin to understand cause and effect and how to control what the object, for instance, a crayon, does. Using materials involves figuring out how they work, what they can do, how they represent objects or thoughts, or how they can be used to express oneself. For older infants, paper and marking materials such as crayons are fine.

Providing infants with pre-art experiences is important for encouraging exploration and expression. Pre-art experiences for infants should be intentional, with teachers planning the experience, determining the learning outcome, and assessing the infants' development through various methods. In the example above, Itunu determined a learning outcome and planned a sensory experience for the infants. As the infants played with the provided textured balls and scarves hidden in a tissue box, Itunu observed them. Writing quick notes, Itunu noticed which infants pulled or otherwise touched the materials. Later she reviewed her notes to determine how to proceed, knowing this experience would need to be repeated and possibly adjusted to reinforce the experience and development for each infant.

Other Considerations

Many websites and resources suggest using food as an art-making material with infants, because it is assumed to be safe and nontoxic. Recipes for activities such as edible paint or playdough are readily available but there are several things to consider and infants' use of food substances for art materials is not recommended (Cryer, Harms, and Riley 2004). Teachers need to consider if any infants have food allergies. Also, there could be unknown allergies. Choking hazards also need to be consider when using small food items such as beans. Using pudding, gelatin, or even apple slices as a medium for creating art can send conflicting messages. The children may go from painting with pudding in the morning to a meal where they are served pudding to eat but not to play with it. It's typical for infants and toddlers to play with their food, which is why offering play or art materials that smell and taste like food is discouraged. Offering play or art materials made of household ingredients, for example, modeling dough made of flour and salt, is different, however, provided children get a consistent message. The modeling dough is treated as a material that children will explore but won't eat, whether or not the modeling dough is made with edible ingredients.

Observing children's behaviors throughout the day will provide clues to what art materials should be introduced. For example, what are the children doing as they eat? Perhaps you notice Zena smearing her mashed potatoes across her high chair. Does she do this regularly? Does she try to smear a variety of foods? Zena may be ready for a smearing activity using an art material. It would be appropriate to introduce finger painting to the morning activities. Make sure you have wash up supplies nearby for easy cleanup.

Older infants should be allowed to engage in individual expression. Let them use the art materials in the way they want, as long as safety is not an issue. For example, a fourteen-month-old may choose to pick up a crayon with each hand

and create marks on a piece of paper. The child may do this for fifteen seconds and then move on to something else. There may be a small number of crayon dots that appear haphazardly placed on the paper. That's okay. That is pre-art. Think of it as the child's experimentation with crayons. As the child continues to use crayons over the next few months, they are learning what a crayon does, that crayons can be different colors, that pounding and pushing may result in different-shaped marks, and all sorts of other interesting facts. This pre-art experience develops the child's understanding of what a crayon is and how to use it, and it strengthens the child's schema, or mental image, of "crayon."

Teachers need to facilitate the use of art materials for older infants. Older infants are developing muscles and awareness of space. They may prefer to use art materials while standing rather than sitting, which may provide better whole-body control. But making marks on paper can be tricky. Often an infant has difficulty holding the paper in place. Taping the paper in place will provide the child with a stationary target for the crayon. Try covering a low table with a large piece of paper and tape it down for all the children to scribble on.

Because infants' abilities vary, access to art materials should be based on each baby's readiness. Plan individual rather than small- or whole-group experiences with art materials and realize that children's experiences with art materials should be optional at this age. This does not mean teachers can't plan art experiences for the group. A teacher can provide the children with paper plates, crayons, and paint. All the children will have access to the same art materials, but each child can choose whether they want to participate and, if they decide to participate, what they will do or create.

Teachers can help families understand pre-art experiences by displaying the children's artwork. Showing the artwork reinforces the infant's efforts and provides families with examples of age-appropriate art. Children's art should be displayed as is. Adults should not change children's work to make it better or manipulate it into something recognizable. In many classrooms, teachers are observed changing the children's art, for example, crayon markings on paper, by cutting the paper into specific shapes to reflect a holiday or theme. What message does this send to the children? Manipulating children's work discounts children's skills and their attempts at expression.

Appreciating Art with Infants

It is never too early to introduce infants to works of art. Providing examples of famous works of art in a care setting is a way to encourage infants' curiosity about their world. Many board books for infants feature works of art. Some, such as *Art for Baby,* are designed specifically for babies using high-contrast black-and-white images. Others focus on a theme, such as numbers or faces, while featuring famous works of art. Yet other board books showcase a specific artist, such as Henri Matisse in *Matisse Dance for Joy.* Books are a way to introduce infants to cultural diversity too. Look for books that present examples of different cultures or artists of various backgrounds. The Recommended Children's Books and Resources list on page 141 provides additional suggestions.

Reading and interacting with art books for babies begins to provide experiences with and appreciation for the works of art around us. Teachers can use art books for babies the same way they use with other types of books. Follow the infant's interest and lead. If the child seems interested in the illustrations, then provide feedback such as, "Oh, you like this page. This is a horse. It's cut from paper."

Personal Reflection and Practice

Prepare: Look around your program to inventory what types of sensory materials are available to use with infants. List materials that have different textures (such as bumpy balls), items that can be crinkled, crumpled, and torn, and natural materials. List any art books you have available. What types of materials are missing? Look beyond your room to see what you can find in storage closets. Review supply catalogs for more ideas, and brainstorm ways to obtain additional materials to use in the setting.

Act: Think about how the materials and experiences are presented to the infants. Introduce a new sensory material, or a new way of experiencing a sensory material, to your setting. For example, group large sheets of various types of paper where infants crawl and move about so that they may feel the different textures with different parts of their bodies. Try introducing new natural materials, such as a segment of wood that has a bumpy bark. Observe how the infants interact with the materials. How do they approach the materials or experiences? What sounds do they make? Think of how you can talk to the infants to provide vocabulary; for example, you could say, "This is wood" to increase a child's understanding of an object.

Reflect: Consider what each infant may have learned from the experience. Did the child interact with the new material in the way you expected? Did the addition of the new material enhance their development in some way?

Sample Art Activities for Infants

Many websites provide recipes and ideas for making art materials for infants. Be sure to check the recipe ingredients for safety before sharing the art material with infants. Test the recipe to ensure it produces the desired texture, cleans up easily from the furniture, floors, and babies, and stores the way you expect.

SENSORY ART Baby Bubble Wrap

To create this sensory play activity, gather up a large sheet of Bubble Wrap (8 x 11½ inches or larger), non-toxic paint, and strong tape, such as brown packaging tape. Paint can be squirted directly on the table (and wiped up afterward) or on top of a layer of paper attached to the table.

1 Place a squirt of a complementary colors of paint on the table or high chair tray.

2 Tape a piece of Bubble Wrap over the top.

3 Encourage the child to squish and move the paint under the Bubble Wrap.

SENSORY ART Sensory Bags

Baby-friendly sensory bags can be made with large, durable, plastic ziplock bags and strong tape, such as brown packaging tape. A variety of materials may be used to fill the bags, such as oil and water; food coloring, shaving cream, and sequins; body wash and confetti; or hair gel and plastic ocean animals. (Note: As noted earlier, shaving cream is not typically safe for use with young children but in this activity the infants are not touching the shaving cream.)

1 Fill the bag with the materials. Remove all or most of the air from the bag so that it won't burst. Do not overfill.

2 Seal the bag and tape it down on a table, high chair tray, or floor.

3 Encourage the children to touch and squish the bag.

Toddlers: Do Messy Toddlers Really Need Free Access to Materials?

Lily looks at the results from her room's Infant/ Toddler Environment Rating Scale *(ITERS-3), which was completed by her quality improvement specialist, Pat. Lily is disappointed with the score she received for art: a two. Lily reads Pat's comments. "You have plenty of room to add an art area, Lily, which would allow the children to choose materials and encourage individual expression. Think about adding an art area." Although this feedback is difficult to hear, it causes Lily to reflect on the room environment. Lily thinks about the active toddlers in her room. How could she allow them free access to art materials? She could imagine glue and paint on everything!*

As infants grow into toddlers, they are able to do more things for themselves. This autonomy and self-awareness typically develops in the second year as the toddlers explore and develop new skills. Their growing self-awareness can be observed when they talk about themselves and begin to express the concept of self, for example, the toddler who yells "Me!" and "Mine!" As a result, the toddler classroom is a very busy place. Art experiences can provide a means for toddlers to develop and express autonomy and self-awareness.

What Is Happening Developmentally

Toddlers, children who are one- to two-years-old, are gaining more control over their bodies, solving more sophisticated problems, and learning to talk. Toddlers are often described as whirlwinds, because they seem to be in continuous motion, moving from one activity to another. They are curious and want to explore the world around them, but they need the security of familiar adults to feel safe and valued.

At the same time, toddlers begin to resist control by the adults in their world; "No!" becomes a favorite way for toddlers exert their personal power. While frustrating for some grown-ups, for toddlers, beginning to explore their independence and learn skills such as how to feed themselves and what tastes and textures they prefer is an important developmental stage. Toddlers' self-concept begins to emerge as they gain confidence in daily tasks. For example, when a toddler successfully zippers their coat for the first time, they feel pride in themselves and self-esteem begins to develop.

The theorist Jean Piaget said that from age two to around age seven, children are in the preoperational stage. Children in this stage are beginning to think symbolically (for example, a unit block can be a pretend brownie), but they do not yet think logically. Children at this stage are egocentric; their thinking is centered on themselves, and taking another's perspective is difficult. Children this age may grab a toy or crayon from another child, not necessarily to hurt the other child's feelings, but because the toddler wants the toy or crayon. Children at the beginning of the preoperational stage, such as toddlers, typically play near other children but not with other children. This is called parallel play, and it's often seen during art and outdoor play. Toddlers like to play with the same materials as their friends or be near their friends, but they are not always able to share or recognize spatial boundaries. Most children accomplish these skills and understandings as they grow toward seven years old.

Through art experiences children can cultivate understanding, control, and sensory development. There are very few places where children can engage with their environment on a sensory level. When children move through stores and other places where products are displayed, many items are wrapped in packaging or out of toddlers' reach. Think of a grocery store. Most often toddlers are seated in the grocery cart. Children can see and hear their surroundings but aren't allowed to touch—to open the packages to feel the things inside, such as pasta or beans. Sometimes adults encourage children to smell or touch the fresh produce as items are put into the cart, but many children are not able to regularly engage with the objects in their everyday environments. They do not have an opportunity to spend time touching, exploring, and observing how the elements and materials in an environment feel, act, and react.

Think of a child care setting with sand and water play, where children fill, empty, pour, and splash in the water. They also push, prod, and pull toys through the sand and observe the paths created as the trucks move through the sand. Most children do not engage with sand or dirt in this way in other settings. They do not have opportunities to scoop up piles of papers or touch paint to notice textures, variations in colors or shading, differences in size, or the feelings against one's skin. Sensory explorations and the introduction of art materials are ways to allow children this type of experience.

One mother complained that her young son often pulled a chair up to the kitchen sink when she wasn't looking and played with the faucet. The teacher told her he wasn't misbehaving, rather, he was trying to figure out the properties of water. Instead of scolding him, the mother was encouraged to give her son tasks, such as washing the cups and silverware each night, followed by a little extra time in the bathtub to explore the water in appropriate ways. Toddlers have a developmental need to explore their senses, and art is a great way to provide sensory experiences.

Toddler Art: "I Do It!"

For younger children, art making is more about exploring materials and learning how to operate tools than producing a specific object. After twelve months, most toddlers have the eye-hand coordination and self-control to engage with art materials. Children this age are less likely to put materials in their mouths. Think about a young toddler using a crayon for the first time. What does the child need to do? Exploring with a crayon, the child must figure out how to hold the crayon, what the crayon does, and what happens as the child handles the crayon in different ways.

It often seems as if toddlers like repetition. They do! They will frequently repeat a behavior or activity over and over. A toddler may scribble on a sheet of paper before gluing an item on it. The same toddler may get another sheet of paper and again glue on a similar item. This child may then move on to another activity—or she may continue gluing one item on a sheet of paper. Toddlers are trying to make sense of their world.

Teachers often notice repetition as toddlers paint. Think about a toddler using a paintbrush for the first time. What does the child need to figure out? Exploring a paintbrush, a toddler needs to figure out how to hold it, which end to put into the paint, and how to move it about. As the child gains control and understanding of the paintbrush, he can experiment with what the paintbrush can do, and then repeatedly practice each new discovery. For example, the child may paint one spot over and over until the paper can't hold any more paint or a hole begins to form.

Young children do not try to create an image of an object. They try to figure out answers to various questions, such as "How does this work?" "What happens if I repeat this?" or "How much paint can I put on one spot?" The toddler may be concentrating on cause and effect. "What if I use my hands with the paint? What happens if I push paint with something else?" As the toddler repeats an action, he observes how the experience is the same or different from a previous experience. This repetition helps toddlers adjust their schemas, or mental images, of objects and how objects work. Toddlers may not be creating art, but they are conducting endless science experiments.

Young children have not developed handedness, so they are likely to use whichever hand is closest to the area they wish to paint. Educators may see young children try to paint with one brush in each hand at the same time, or they may observe them painting with one brush that they switch from hand to hand. Toddlers' experiments with manipulating materials and controlling tools are preliteracy skills. Children need to develop upper-body and arm control and strength before they can learn to read and write. Fine-motor skills will allow children to hold books and turn pages. Using upper-body control to experience art helps toddlers develop the finger muscles they need to grasp pencils and other writing utensils, and to hold paper as they make marks and eventually letters.

By age two children are beginning to develop some control as they continue to scribble. Scribbling is making marks rather than drawing specific symbols for

objects. At first, while their focus is on operating the writing utensil, toddlers' marks on paper will be random scribbling. These types of marks are about movement. Scribbling allows children the opportunity to engage in movement and enjoy the act of making marks. Scribbling is investigative. As children scribble, they increase their fine-motor control and understanding of how to make marks. Next as young children gain more control, they begin to make various lines, such as wavy, zigzag, or circular. Around age four the children begin to introduce geometric forms, such as circles, triangles, and squares, to their drawings. The shapes will not be crisp, closed figures, but the appearance of a shape emerges.

The child's move toward controlled scribblings or drawings signifies an important developmental step. The child begins to name what he draws as he consciously tries to represent objects and people. Although the drawings may not be recognizable to adults, the child recognizes that drawing can have purpose. Toddlers and young preschoolers often draw or paint familiar objects, such as a sun or family member. As children move from the toddler phase to preschool, their drawing changes from a motor activity to an activity reflecting expression of the child's relationships and language.

What Does Art Look Like for Toddlers?

Carefully planning an art center will increase children's successful use of art materials. There should be a wide assortment of art materials available, and teachers can choose whatever is appropriate for the group while ensuring variety and choice. Of course, all materials need to be nontoxic and safe. Using age-appropriate materials that support children's fine-motor development will often minimize frustration. For example, a large container of glue is heavy and often encourages toddlers to squeeze out all the contents. Using smaller bottles helps children develop their fine-motor skills and is easier for them to manage. Providing something else to squeeze and empty (such as at the water table) will also help satisfy this developmental need.

Once the materials have been selected, give the art area structure by defining the work space; perhaps it will be an easel and a large table near the art shelf. Think about the amount of time available for art, where the projects will be laid out to dry, and what cleanup procedures will be followed. Typically, the children will call a teacher for help when they are finished. Provide children with guidance on how to use the art area. Then the children, including toddlers, can use the materials and clean up independently. Let the work space and the children's age guide your decisions.

The ITERS-3 (Harms et al. 2017) also provides guidance in setting up a toddler art center. When scoring the indicator for art, programs will receive a 1, the lowest score, if no materials are provided to the children, or if toxic or unsafe materials, such as shaving cream, glitter, permanent markers, or things that children can choke on, are provided. For a "minimal" score, some art materials must be used at least once a week, all materials must be nontoxic and safe, and children must not be required to participate. For a "good" score, younger toddlers must be offered art experiences three times a week, individual expression must be encouraged, and staff must facilitate appropriate use of materials such as securing paper as a child uses paint or crayons. Last, for the highest score, a seven, or "excellent," a variety of materials must be introduced to the children, and access to materials must be provided based on children's abilities.

Children need free access to the materials in an art center during the free play or exploration portion of the day. Focus their efforts on two types of creations: two-dimensional, or flat, art, which includes drawing, painting, and collage, and three-dimensional, or 3-D, art, which involves playing with materials such as dough. It is important for toddlers to have both two- and three-dimensional art experiences, so an art center should be stocked with materials that support flat and 3-D art.

Let's return to Lily's story from the beginning of the chapter. Although she was sure it would create a big mess, Lily followed the quality improvement specialist's recommendation. She reluctantly pushed the storage unit and easel out of the corner and created an art area. She found a small rectangular table in a closet that was the correct height for toddlers. Lily looked at her copy of the *Kansas Early Learning Standards* for guidance. The creative arts indicator CA.t.14.a stated, "Explores a variety of art media: painting, gluing, printing, fingerpainting, clay, etc." (Kansas State Department of Education 2014, 60). Lily also noticed that the physical indicator in creative arts mentioned gripping crayons, while the creating indicator stated, "Explores and manipulates sensory materials" (60).

Based on the information from her state's *Early Learning Standard*s and the ITERS-3, Lily decided to use "Explore various media and sensory materials" as her learning outcome for the art center that week. On her planning form, she wrote the learning outcome as "Children explore and manipulate sensory materials in the art center." Lily decided she would record observations during the week using sticky notes, which she could easily put into each child's folder.

Lily stocked the area with crayons and chalk, small containers of glue, white and color construction paper, chunky pencils, and collage-making materials that were also sensory items, including large cotton balls, pom-poms, and pieces of fabric. She organized each supply in a clear container, and she placed each container on a shelf where it would be visible to the toddlers. She created a label for each container that included not only the name of the item, to provide an example of the word in print, but also an image of the actual item, since the toddlers couldn't read. Her art center was off to a great start. To assess the learning outcome, Lily will refer to the observations she recorded on sticky notes throughout the week. She will also review her observations before planning the next theme and learning outcome.

Toddlers' ability to choose what they want to explore and use through access to an art center increases their independence. Their confidence is strengthened when adults encourage age-appropriate independence. Toddlers who are shamed when they make mistakes, or restricted from trying new things, have difficulty building confidence. Allowing choice is one way adults can encourage independence. Toddlers should have a choice about participating in activities, including art.

Integrating art in a toddler room is more than adding an art center. It's about supporting toddlers' physical and social development as they engage with art and sensory materials and create art. Many classrooms provide crayons as a child's first writing utensil. Rosalind Charlesworth (2014) explains that markers and felt pens are the easiest writing material to use; they require little pressure to use or leave marks. Chalk is also easier for young children to control. But of

course, crayons can be provided. These materials are available in many shapes and sizes, and having a choice of materials, types, and sizes (chunky crayons, regular crayons) will facilitate each child's interactions with the materials. Other ways to support toddlers include:

- If toddlers are struggling to hold paper as they make marks, scribble, or glue, tape down paper for support.

- Ensure that there are sufficient supplies so that children aren't fighting; toddlers are not good at sharing.

- Think of cleanup. Ideally an art center should be near a low sink that a toddler can use independently. If this is not possible, then are there wet wipes, paper towels, or other cleanup supplies nearby?

These ideas will help teachers consider how the environment and materials in a toddler room can support the children as they engage in creative art.

What "Art" Should I Do?

Art is not well defined in early childhood. Teachers struggle with what "doing art" means. For a child, art is the result of the manipulation of and response to materials. It is evidence of the child's thoughts (Goldberg, accessed 2018). Of course, this book focuses on supporting open-ended art, with the idea that using or creating art materials is a form of expression.

Educators often see an increase in structured crafts in toddler classrooms. They frequently report that parents want artwork that looks like something. Parents see the cute handprint flowers or lions made from paper plates and immediately recognize what was made. In their mind, a paper plate lion will look great hanging on the refrigerator. But teachers of young children need to develop an understanding of what the children are doing as they create open-ended art. Teachers should be able to explain this process to parents in a way that makes sense.

Many times, parents are worried about whether their child will be ready for school. Parents sometimes see art as silly, an add-on, or unnecessary. Teachers need to articulate the importance of art and the importance of letting children engage in creating art. Stanford University professor of art and education Elliot Eisner states, "The arts teach children that problems can have more than one solution and that questions can have more than one answer. The arts celebrate multiple perspectives. One of the large lessons kids can learn from practicing the arts is that there are many ways to see and interpret the world" (Robertson, accessed 2017). Explaining to parents that art encourages toddlers to engage in problem solving and develop the fine-motor muscles and body control that are needed for reading and writing will help them understand why the toddler room has an art center and why their child is the one choosing what to create.

TABLE 6.1. Examples of Toddler Art Guidelines

STATE (DOCUMENT)	EXPRESSION AND REPRESENTATION STANDARDS	RESPONDING OR REACTING STANDARDS
New York State Early Learning Guidelines	Children use creative arts to express and represent what they know, think, believe, or feel.	Children understanding and appreciating of the creative arts.
Pennsylvania Learning Standards for Early Childhood: Infants-Toddlers	Infants and toddlers will demonstrate an increased understanding of the basic elements of visual arts.	Infants and toddlers will use imagination and creativity to express self through the process of art.
Louisiana's Birth to Five Early Learning & Development Standards	Developing an appreciation of visual arts from different culture and create various forms of art.	Demonstrates creative thinking when using materials, solving problems, and/or learning new information.

Chapter 3 discussed how to write learning outcomes based on standards or guidelines. Learning outcomes can also help parents understand what standards or guidelines for toddlers (or for any age group) look like. For toddlers, many state and program documents have a guideline for expression and representation and a guideline for responding or reacting to visual art. Table 6.1 (Louisiana Department of Education 2013; New York State Early Childhood Advisory Council and New York State Council on Children and Families 2012; Office of Child Development and Early Learning 2014) provides examples of these guidelines from three states.

These state or program documents provide information for various age groupings, such as Young Infants, Older Infants, and Toddlers, or age bands, such as birth to eighteen months and eighteen to thirty-six months. The documents typically provide standards and indicators and often some examples of which activities or materials can be used in the classroom or setting. Some documents even provide sample questions or statements for teachers to use. Most states have early childhood guidelines, but not every state has guidelines for infants and toddlers. The National Center on Early Childhood Quality Assurance has a listing of each state's early learning guidelines (2017). If your state doesn't have early learning guidelines, refer to another state's for suggestions. See also the Recommended Children's Books and Resources list on page 141.

Thinking about the process involved with using art materials with toddlers may help teachers with planning. What process is being emphasized? Are the

toddlers learning how to make marks or how to glue? If toddlers are becoming frustrated with a process or tool, then they may need some guidance or modeling to figure it out. Imagine a toddler working with a crayon. The child has figured out how to scribble, but the crayon is a bit worn. A bit of the crayon's paper wrapper needs to be removed, but the toddler hasn't figured this out. Before the toddler gets extremely frustrated, a teacher unwraps part of the crayon, explaining this to the toddler as she does.

A teacher may plan to provide small group instruction that focuses on introducing a material or process. The undertaking should not be teacher-directed, step-by step creating, rather, it should be a conversation between the teacher and the toddlers. Imagine the children are pounding dough, and a teacher feels some of them are ready to roll the dough. Sitting with a few toddlers, the teacher should roll the dough and talk about the process; this will help the toddlers experiment with techniques.

Lily, the teacher at the beginning of the chapter, observes the children after she introduces the art center. She had feared the children would make a mess and leave the art supplies throughout the room. She notices that when the toddlers use the art center and its materials that some of the other classroom areas get less messy. She wonders if perhaps the toddlers needed an outlet for expression.

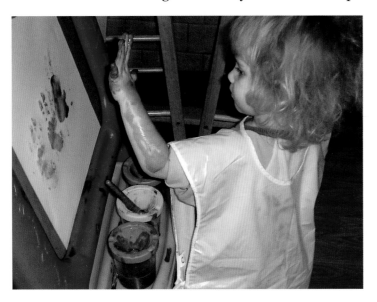

During art each day, Lily kneels with the toddlers. She talks about the materials as she creates a collage or uses the recently added soft dough. Lily never realized how much vocabulary and concepts could be introduced in the art area. After a couple of weeks, Lily decides to gradually introduce new materials to the art center.

Notice that the examples in table 6.1 include an indicator focusing on toddlers demonstrating expression related to art. When doing art, toddlers need to have autonomy to complete their work on their own. An early childhood educator might see a child complete the same picture over and over at the easel as they attempt to get it "just right."

When you notice this in your classroom, stop and observe. Watch the child and observe their movements and expression. Are they smiling with a look of confidence, or do they furrow their brow as if to solve a problem? Is the child watching the painting as it drips down the paper? The child may be wondering how long the drip will become. The child may take the brush and poke or jab it onto the paper as they contemplate what type of marks will occur. Observing

what happens as art materials are manipulated helps toddlers learn about cause and effect. They begin to gain control over the movement of their fine-motor muscles as they experiment with the amount or kind of control or pressure various materials and tools need to operate.

Adults frequently want to label or identify children's artwork. As children are better able to express their ideas and thoughts, they often hear adults asking, "What did you make?" Many adults look at a child's creation from their own point of view rather than from the child's. A child is content with exploring, focusing on the manipulation of the materials. It's their process. And adults have learned that it's not appropriate to ask a child what a work of art is, so they say, "Tell me about this" or "Tell me how you made this." Young children may not be able to respond to these prompts.

Other Considerations

As toddlers gain more control over their bodies, adults need to respond with more opportunities to promote toddlers' independence. With art, teachers will often provide toddlers with materials and tools that they would not have likely given to infants, such as scissors. Providing toddlers with opportunities to learn how to use new materials and tools recognizes their increasing abilities and curiosity.

Toddlers often seem capable of anything. They may firmly state, "I do it!" and insist on trying. While toddlers can do many things and use many tools, it is important for teachers to consider each child's individual experiences and abilities as materials and tools are put into an art center. Some toddlers will pick up a tool, such as scissors, and be ready to use it. Other children may use the tools in a dangerous manner, such as waving an open pair of scissors overhead. Teachers need to introduce items slowly and carefully to ensure they are used safely and appropriately.

Some families may be cautious about introducing their child to certain art items. This could be due to concern about the item, such as a tool that could be harmful or messy. There may be a cultural reason that a toddler has not used a material or tool. For example, in some cultures or families, a neat and clean child is an important reflection of the parents or family. Parents may hesitate to provide potentially messy materials, such as paint or chalk, to a toddler who can't quickly clean himself.

A child care setting may be the first place a toddler has the opportunity to use art materials and tools. It is important for teachers to think about which materials and tools need introducing and how to introduce them to toddlers. Does the tool and accompanying material match the child's ability or skill? Using scissors as an example, are the scissors being provided designed to cut only paper? Are

they designed to be used with left or with right hands? By the time they are two years old, most children show a marked preference for using one hand more than the other, although some may still occasionally switch hands (Petty 2016). Teachers should consider activities or tasks that will support toddlers in their learning of how to use art materials or tools. A child with no exposure to scissors may need to be shown how to operate them and may need to practice cutting a variety of materials of increasing firmness, such as dough, modeling dough, thin craft foam, and then paper, before she will be able to manipulate the scissors well enough to cut a specific item, such as fabric or cardboard.

Teachers should also consider how toddlers learn to clean up art materials and tools. Toddlers are just beginning to learn how to clean up after themselves. Show toddlers how to put art materials back in labelled containers and finished art where it belongs, such as on the art counter or in their cubby. Creating and teaching procedures through modeling, reminding, and visual cuing applies to the art center, materials, and tools just as in other areas of the classroom.

Appreciating Art with Toddlers

The idea of toddlers participating in art appreciation may seem silly to many people, who think these babies are too young! State standards or guidelines suggest that infants and toddlers can begin to appreciate art and art elements (see examples in table 6.1). What follows is a discussion of ways to easily add art appreciation to a toddler setting.

Early childhood educators love books. Just about any toddler setting contains books, and reading to toddlers is part of the daily routine. Teachers should include books about art in the toddler environment and should choose them to read with the children. Many board books that feature artwork are designed for infants and toddlers. Some feature various works of art depicting a common object, such as *The Bunny Book* from the Metropolitan Museum of Art, which contains images from the museum's collections. Books for toddlers can also focus on the artwork of a culture while providing images of common objects. *Learn the Colours with Northwest Coast Native Art* focuses on the basic colors while featuring artwork by people indigenous to that area. Early childhood educators

can ask questions, provide language, and help toddlers interact with books about art as they would with a storybook. Local children's librarians can help educators locate age-appropriate materials. If a local library doesn't carry many age-appropriate art books, then ask if it is part of a regional borrowing network. Many libraries take patrons' suggestions for future purchases. Ask about the type of book you would like to see the library acquire.

Personal Reflection and Practice

Prepare: There are many words that toddlers can learn through using art materials and creating art. Look at the art materials in your room. Think about a material or a material's property that you would like to focus on.

Act: Brainstorm all the words associated with the material or its property to create a word box. For example, imagine "paper." The teacher's word box might look like figure 1.

Reflect: Reflect on how adults can promote language through art and art materials. Consider identifying a couple of target vocabulary words each week or month in the art center. Try creating word boxes throughout the year for different materials, and share these with the toddlers' families. The word box may serve as part of a bulletin board documenting toddlers art creating!

FIGURE 1: Sample Word Box for Paper

colored	tracing	wrapping	scrapbook	tear/torn
long	short	rough	sandpaper	crumbled squished
fold	rip	unfold	newspaper	magazine pages cards
tissue	transparent			

Sample Art Activities for Toddlers

There are many sources of art activities for toddlers online, in teacher magazines, and elsewhere. When searching for ideas, keep developmentally appropriate practice in mind. Below are a couple of favorite toddler activities.

Cotton Ball Painting

For this activity, you will need a muffin tin, brownie pan, or paper plates to hold small quantities of paint, plus washable paint, some wooden clothes pins, cotton balls, and paper to paint on.

1 Add dollops of a few different colors of washable paint to a muffin tin, brownie pan, or paper plate.

2 Attach wooden clothes pins to the cotton balls and place one in each dollop of paint.

3 Set the muffin tin (or brownie pan or paper plate) out for the children and encourage them to dab the paint onto paper.

Collaborative Project: Stained Glass Windows

This project requires canvas (any size, depending on what you hope to achieve), masking or painter's tape, paints, sponge brushes, and gesso (optional).

1 Line up the canvas on a low table.

2 Roll the tape from one side to the other at different angles.

3 Paint gesso over the tape to prevent the paint from bleeding under the tape (optional).

4 Give the children time to paint the canvas.

5 When the paint is dry, peel off the tape to see the pattern left behind.

6 Hang the canvas on the classroom wall. If the children paint more than one canvas, then hang them in a row.

Preschoolers: What Does Art Look Like in the Preschool Classroom?

For the first week of preschool, Sheila plans a theme, "All about Me." Each day she plans a few activities to get to know the children and their interests. On Friday, she reads a book about families and then encourages the children to create pictures of their families in the art center. As she heads over to observe their work, she notices that most of the children are drawing with crayons or markers on white paper. The children of color have outlined their figures and colored them in brown with black eyes, while the white children have not colored the figures but left them as outlines on white paper. Sheila realizes that the writing materials available, such as crayons and markers, do not offer enough choices for the children to accurately represent themselves.

Growing preschoolers have developed and mastered a number of skills, and they continue to gain self-control and independence. As a result, they need more freedom to explore activities and be responsible for their own learning in an early childhood classroom setting. Learning centers can be expanded to provide new and different opportunities for learning. Language and literacy remain an important aspect of any classroom environment area. Preschool children continue to express themselves through language, and newly developing forms of expression, such as writing, begin to emerge. Art provides an excellent opportunity to cultivate these new skills.

What Is Happening Developmentally

Preschoolers begin to master large-motor movements and have greater control over their fine-motor muscles. Preschoolers begin to use and control scissors, though many won't master cutting figures until they are approximately six years old.

Expanding on experiences, preschoolers have a growing number of mental images, or, schemas. A preschooler's representations are based on her interactions with real objects, people, and experiences. For example, a child living on a farm who helps care for animals will have a very different schema, or mental

representation, of cows, horses, or pigs compared to a child living in a large city who sees these animals only at the petting zoo. Preschoolers need concrete experiences with people, events, and objects to continue to develop their schemas.

The theorist Jean Piaget described children ages two to seven years old as typically in the preoperational stage of cognitive development. Piaget explained this stage of cognitive development as the ability of a child to think symbolically. To think symbolically is the ability to have one object stand for another object. Children this age are learning about numbers and counting. A child in the preoperational stage will begin to understand that "2" can represent two objects or someone's age. Children in this stage are also able to pretend small blocks are chicken as they "fry dinner" in a dramatic play area.

Preschoolers are still egocentric, or self-centered, but most preschoolers are increasingly interested in friends and doing things with friends. Creating art can promote development in several domains. Physically, children work on using fine-motor muscles. Cognitively, they increase their vocabulary and mental schemas. Art can also serve a social development role through expression, listening

to others, and beginning to understand that others can have different perspectives or points of view. One way children of this age learn is through drawing. Viktor Lowenfeld and W. Lambert Brittain (1975, 165) argue that drawing helps preschoolers "establish some sort of conceptual organization." Drawing refers to creating lines, images, symbols, and number- or letter-like writings.

Preschoolers use drawing as one way to figure out relationships and the sequence of events; after all, time is still an abstract concept. Teachers will continue to observe repetition in preschoolers, but the purpose behind the repetition changes. Preschoolers tend to repeat figures to ensure mastery over forms and may use repetition to adjust their schemas. For example, a child may know a triangle has three sides. She may know the sides should be straight but she may not be able to draw straight lines. Her attempt at lines are wobbly, which is typical for a preschooler. Repeated practice drawing triangles will increase the child's ability to draw straighter lines and reinforces the properties of a triangle.

Preschoolers are beginning to create art ranging from simple forms to more complex and more recognizable forms. Spontaneous representations continue but begin to change as a result of greater focus on purposeful or intentional representations (even if an adult is unsure what it is). Children create external representations through representative, not literal, translations of experiences, objects, or people. Preschoolers may focus on a certain aspect, relationship, or function. For example, a child may practice how to draw faces. A child's attempts may be exaggerated in size or proportion or contain exaggerated features.

During this age, children move toward controlled scribblings or drawings, which signifies an important development step. It signals that a child is consciously trying to represent his environment and objects in it, moving from scribbling as a motor activity to an activity reflecting expression (emotions, language, social relationships).

Children don't suddenly draw recognizable shapes at age four. Developmentally a child progresses from marks on paper to lines that eventually become shapes and then complex figures. This development will depend on the child's interests, motivation, and experiences. There may be shapes on the child's paper, but the teacher may not be able to tell if a specific drawing is a house, person, or something else altogether.

Children's representations are not a precise record of what they know. Representations are often representative of relationships; their participating in art may be accompanied by their creating a story or narration. The more aware a child is of his surroundings, the more details will be present in the child's representations, if the child is capable of making details. Most children begin drawing people using a large circle for the head and two vertical lines for feet. Early drawings spring from scribblings, where circular movements and lines are

dominant. Children know people have more parts than a head and two feet. For example, children know people have facial features, fingers, and toes, but these body parts aren't often evident in early drawings.

For preschoolers, drawing a representation of an object is often of more importance to them than their concern for color. In fact, there is frequently little relationship between the colors they use and the drawings. Children will often choose colors they like or use a color to represent one feature of the drawing without focusing on proportion. For example, a child may use red to draw his father "because my daddy likes red" or "Uncle Joe always wears a blue hat." Color choice may have more to do with material issues, such as which paint is thicker and doesn't run or which crayon's wrapper exposes enough crayon to use without trying to remove more wrapper. Children are building understanding of color and how color impacts representations.

Space is also a developing concept. Initially children tend to draw or place objects in relation to their spatial perspective. A child may put an object, such as a truck, at the top of a painting, not because she thinks trucks are above, but because she perceives the truck as being "over there" or "over a hill." Understanding children's development of drawing, shapes, proportion, color, and space provides insight into children's artwork.

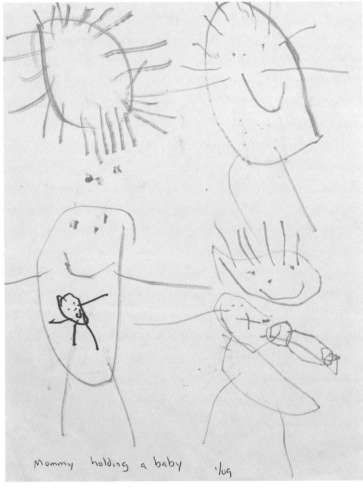

What Does Art Look Like in Preschool?

Art is not the same for both adults and children. Viktor Lowenfeld and W. Lambert Brittain (1975) state that most adults think of "art" as works hanging in galleries or museums. For many adults, art has aesthetic qualities but is something that someone else does. Children on the other hand view art as a form of expression. The Reggio Emilia educational philosophy refers to the "Hundred Languages of Children" (Edwards, Gandini, and Forman 1998, 32). The "Hundred Languages" refers to the various ways children learn and express their thoughts and feelings. Participating in open-ended art experiences offers children a language for learning and expressing their thoughts and feelings. The world today is a highly visual world full of images produced in videos, films, books, television, advertising, and many other media forms. Some teachers report preschoolers arriving with preconceived ideas about what art is. These children often think art is copying forms, coloring in adult-created images or in coloring books, or, as one four-year-old told us, "Art is making something the teacher wants you to make." Although none of these things, coloring a worksheet, copying an image, or creating a teacher-directed craft, is wrong, none of these activities is truly open-ended art and none will allow children to express their point of view.

It is important that children develop a broader understanding of art and their ability to make art. Children should be encouraged to experiment with materials and techniques to create personal art rather than replicating someone else's art. A teacher may introduce a book study that focuses on an illustrator's techniques, such as using tissue paper and found objects. The teacher and children may discuss how the illustrator created the book's images, and the illustrator's work may be inspirational. Teachers can help children differentiate between using models for inspiration and creating exact replications.

Most children have engaged in some basic art making, including painting, drawing, collage, and dough or clay. Preschoolers can begin to learn about the elements of art: lines, color, shape and form, and texture. Artists use elements to portray feelings. Preschoolers are capable of discussing feelings, and the elements of art can be a tool, or language, for expressions. There are many books that focus on various feelings and on how people look as they experience feelings. Many state standards or guidelines begin to expect preschoolers to describe their artwork in terms of the elements. See table 7.1 below (Michigan State Board of Education 2005; Louisiana Department of Education 2013; South Dakota Department of Social Services 2016):

TABLE 7.1. Examples of Preschool Visual Arts Standards

STATE (DOCUMENT)	EXPRESSION AND REPRESENTATION STANDARDS AND INDICATORS	APPRECIATION (RESPONDING OR REACTING) STANDARDS AND INDICATORS
Michigan: *Early Childhood Standards of Quality for Prekindergarten*	*Early Learning Expectation: Visual Arts. Children show how they feel, what they think, and what they are learning through experiences in visual arts.* This document lists 4 indicators for this standard including: ** Begin to show a growing awareness and use of artistic elements (e.g., line, shape, color, texture, form). ** Create representations that contain increasing detail.	*Early Learning Expectation: Aesthetic Appreciation. Children develop rich and rewarding aesthetic lives.* This document lists 10 indicators for this standard including: ** Are comfortable sharing their work and ideas with others. ** Begin to develop creative arts vocabulary.
Louisiana's Birth to Five Early Learning & Development Standards	Standard CC 2: Develop an appreciation for visual arts from different culture and create various forms of visual arts. This document lists 3 indicators including: ** Describe specific elements of a piece of art (e.g., texture, use of color, line, perspective, position of objects included). (4.2)	Standard CC 2: Develop an appreciation for visual arts from different cultures and create various forms of visual arts. This document lists 3 indicators including: ** Create artistic works that reflect feelings, experiences, or knowledge using different materials and techniques. (4.3)
South Dakota Early Learning Guidelines	Standard 1-Visual Arts This document lists 6 indicators including: ** Describe experiences, ideas, emotions, people, and objects represented in their artwork.	Standard 1-Visual Arts This document lists 3 indicators including: ** Show appreciation for a variety of art, including that of their own culture and community, as well as others.

Standards and guideline documents provide guidance about what types of art and art appreciation should be included in a child care setting or classroom. These can be used in developing age-appropriate learning outcomes, planning activities, and thinking about assessments.

The Early Childhood Environment Rating Scale, ECERS-3 (Harms, Clifford, and Cryer 2014), the nationally recognized rating scale designed to assess preschool group settings, can be used to help improve the overall quality of the environment. For the purposes of this book, the portion of the rating scale that provides guidance about children's access to art materials is emphasized. As described in chapter 2, the ECERS-3 suggests five categories of materials for an art area: drawing materials, paints, three-dimensional materials, collage materials, and tools. Programs would receive a score of one, or "minimal," when art materials are rarely accessible or when no individual expression is encouraged (for example, when the children have only coloring worksheets or complete the same closed-ended or structured project). For a score of "good," children need to have access to a variety of materials for about one hour during the environmental observation; the children can use the materials in their own way; and staff have conversations with interested children about their work. For a score of seven or "excellent," the staff need to meet the previous indicators plus teach children how to use more complex art materials, provide some materials related to current themes or interests, and write captions dictated by interested children about the artwork (Harms, Clifford, and Cryer 2015, 49). These criteria provide guidance to art materials and access, while the standards documents provide guidance on planning outcomes.

Children love to collage with various papers and cutouts. Educators can adapt this love of collage to focus on elements. Have children cut out items from magazines or newspapers based on an element such as color, then sort the cut pieces into individual containers. Using the cut pieces, create a collage representation, such as a color wheel. This could be tried with lines (straight, curvy, wavy, zigzag), but teachers may need to preview magazines and sources to see which types of lines can be located. Collages could be based on a texture or specific material, such as a collage of different papers. Children are creating art that has a specific theme or material, but the children are allowed to experiment, creating personal interpretations of the theme.

Teachers need to be aware of development and the foundational experiences children need as techniques and elements are taught. The use of scissors is an example of thinking about development and foundational skills. Before children can cut out a curved, multiple-sided figure, children need to have the ability to use scissors and to handle and turn paper. But before children can handle scissors, their fine-motor muscles need strengthening. If children aren't able to demonstrate the foundational skills or have foundational understandings,

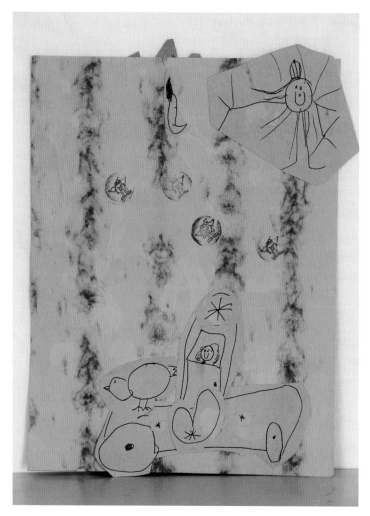

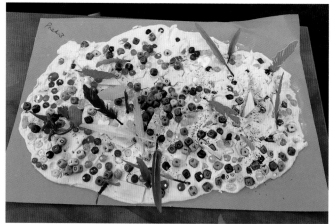

then teaching or demonstrating more advanced techniques may be useless or frustrating. A child who has never held scissors will be very frustrated if she is expected to cut out a circle. Another child in the same setting who has mastered scissor use will be bored if the educator plans an activity about snipping paper or removes scissors from the art center altogether. It is important to consider children's development and skill level. The materials in the art center need to support all children.

Preschoolers, or any children in an early childhood setting, need to be in an atmosphere where it is okay to experiment, to try, and to not succeed. Creating art is about experimenting, problem solving, and trying new ideas. Work with children to develop routines for getting and putting materials away. Develop procedures for taking care of mistakes or accidents. Teachers should model routines and procedures and help children practice them. Allowing preschoolers the space to safely discuss and try their ideas will allow children to be creative in their art making and in their cognitive tasks.

Many teachers use digital images to organize classrooms or to create learning materials in other areas of the room, but digital images can also be used in art making and appreciation. Some suggestions for using digital cameras to support art include:

- **Record process.** Use digital cameras to record children's work process, including their arrangement of materials.

- **Documentation.** Use the camera to document projects and collect information for families, for example, for portfolio assessments or conferences.

- **Classroom books.** Take pictures that can be used to create classroom books to be shared or displayed in the book center.

- **Art materials.** Children enjoy using photographs or parts of photographs in their artwork; they enjoy cutting out people and faces in a collage. Imagine children cutting out pictures from a photograph, layering tissue paper to create a scene, and adding paint to emphasize parts of the scene.

Other Considerations

Preschoolers notice differences among people. Early math and science activities have preschoolers classifying and sorting objects and labeling the groups. It is only natural that children would think about classifying as they engage with materials throughout the classroom, including the way that people can be sorted or classified.

In the opening scenario, Sheila knew that children share a variety of shapes and sizes and many different skin tones and textures, but her art-making materials did not offer much variety for creating realistic portraits or art illustrating people. As she thought about this and listened to the children in her room, she heard them labeling one another: "You're white," "You need this crayon; you're black," or "You can't use that figure; you're not that shape. You need a tall people." Shelia wondered how to handle these statements, even though the children seemed to making observations, not engaging in adult stereotyping.

Shelia did some reading and talked with her supervisor about ways to support children's interest in peoples' appearances. She integrated activities and ideas from the book *Anti-Bias Education for Young Children and Ourselves* (Derman-Sparks and Olsen Edwards 2010) and from Teaching Tolerance (www.tolerance.org). Shelia also included books about people and about artists who depicted people. She and the children had many interesting conversations about people. In terms of art making, the class discussed colors of skin, textures of hair, and body sizes and shapes. As Shelia and the children worked through these ideas, new materials were added to the art center, including multicultural paints and markers. Some materials, like the preformed gingerbread people shapes, were

removed. "Look," a child commented one day while talking to a classmate, "I can draw all family in the right colors." Shelia smiled knowing the class was creating more realistic art about people.

When choosing materials for the art area, teachers should consider which holidays and special days their students and families might celebrate at home and in the wider community. If materials such as scraps of holiday paper, holiday cards, or stickers are part of an art area, teachers may want to consider whether all the families in the program celebrate that holiday. If they determine that everyone does celebrate a specific holiday, then they should consider whether the material is representative of all families. If all families do not share the same holiday celebrations, then teachers may want to consider the message children and families receive when their celebrations are not present in the art materials and then discuss possible solutions.

Adrian, a preschool teacher, often collected scraps of wrapping paper and old cards and placed them in the art center. Adrian thought the children would enjoy using the materials in collages and other projects. He was surprised when a parent asked if he had wrapping paper scraps for all holidays. Adrian thought about the question and began to wonder how the children feel when they don't see collage materials for their own special celebrations or images that look like them. After some reflection, he began to collect crayons, paints, and paper that showed the diversity of the children in his room. Adrian decided to remove the holiday-themed collage materials, because he wanted the materials to reflect the diversity of all the children. He brought in nonholiday wrapping paper and tags and cards that reflected everyday objects and events. Even so, Adrian noticed the children often created holiday-related art as a holiday approached. Since the children were the ones initiating the art, Adrian felt this was appropriate.

All early childhood settings contain diversity. Even when all the children appear to be similar, they have different genders, ages, and families. Teachers can support children's understanding of diverse ethnicities, races, and nationalities in varying ways depending on the children's ages. Preschoolers notice differences. They are curious about hair, skin tones, people's families, body shapes, and so many other concepts. Ideally the art materials will reflect various images of people. It's important to ensure that the materials provided are culturally responsive. In other words, every child in your classroom should be able to find crayons, markers, and construction paper that they can use to represent themselves, their families, their friends, and their community.

Appreciating Art in Preschool

Preschoolers are immersed in the world around them. Their schemas are changing as they learn about families, communities, and neighborhoods. Many preschoolers

have strong preferences about what they like and dislike, and their preferences change frequently. Preschoolers are also sharpening their observation and classification skills and often wonder, "How do you do that?" These qualities make preschool a great time to include art appreciation in programs.

One way teachers can support art appreciation is by providing preschoolers with opportunities for discussion. As mentioned, preschool is a time to begin investigating elements. There are many books that discuss artists and their techniques and the elements. One example is *Look! Look! Look!* by Nancy Elizabeth Wallace. In this book, a family of mice finds a postcard with the painting *Portrait of a Woman* by Robert Peake on the front. The mice examine the portrait and experiment with elements as they observe and admire the postcard. Preschoolers would be interested in learning how artists use the elements to express feelings.

Engaging in viewing and discussing works of art can provide motivation for preschoolers to try to create art based on these conversations. When the group is studying lines, a teacher may use some of Piet Mondrian's work, such as *Composition with Red Blue and Yellow*, an example of what Mondrian called neoplasticism. This print looks as though it may have been very elementary to create; it appears to be a gridlike arrangement of lines and blocks filled in with different colors—all part of artistic elements! Children may enjoy the opportunity to make art inspired by Mondrian's work or others'.

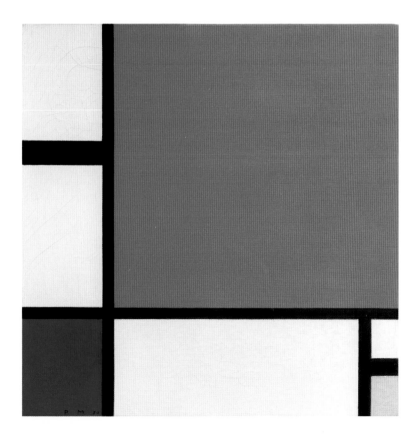

Personal Reflection and Practice

Prepare: Observe children to see how they use a regularly stocked material in the art center, for example, construction paper. Are the children using the material in a variety of ways, or do most children use the item the same way?

Act: Develop a plan or strategy to investigate the material in more depth with the children. Introduce the investigation to the class or a group of children by sharing what you observed: "I've been watching how everyone uses colored paper. I noticed that most of us cut the paper and then glue it on another sheet of paper. I'm wondering how else artists may use paper." The investigation could take many paths. The class or groups of children could look at artwork online or in books, or perhaps a field trip could be taken. Once the group engages in an investigation, the class could brainstorm ways to can use the material differently. There may be additional types of the material the children would like to use, or there may be tools that could be added to the art center. The teacher should encourage children to implement the results of the investigation.

Reflect: Observe the art area to see whether the children change the way they use the stock/standard material. Put some of the results of the investigation, such as photos of a field trip or books about the material, in the art area and other classroom spots. Engage in interactions with the children about the material. Based on observations and interactions and the children's developmental needs, establish a few small groups that focus on advanced technical skills or on reinforcing basic skills.

Art Activities for Preschoolers

Marble Painting

Before beginning, you may wish to show the children some images of natural stone marble. To create marble paintings, you need to provide nontoxic, odorless shaving cream, paints, one craft stick (optional), paint brushes, one paper plate or tray, construction paper, and one piece of cardboard with a straight edge.

1 Put a half-inch layer of shaving cream onto the tray or paper plate. Use your cardboard edge to make the shaving cream level.

2 Children should gently paint designs on top of the shaving cream. You may need to demonstrate what gentle painting looks like; the children should paint on top of the shaving cream and should not break the surface.

3 Gently swirl the paint using a paintbrush or craft stick.

4 Gently press the paper onto the shaving cream. Let the paper set for a few seconds before gently lifting the paper off the cream.

5 There will be blobs of shaving cream on the paper. An adult can assist the child in scraping the shaving cream off the paper.

6 Once the painting is dry, the remaining shaving cream can be rubbed off with a towel.

Creating Photomontages

A photomontage typically combines several photos or parts of photos to create a visual image. To create a photomontage, the children need glue and construction paper or paper bags for the background. There are many different collage materials to choose from: photographs, tissue paper, fabric scraps, foil, comic and newspaper pages, wrapping paper, and pages from catalogs and magazines.

1 For the background, have the children select a piece of construction paper or cut open a paper bag. Experiment with different sizes of paper for the background.

2 The children should select materials to begin the montage; it's typical to start with photographs or magazine clippings. Move the materials around to find the right location on the background, and then glue the pieces down.

3 Children can add other collage materials to their work, gluing each piece onto the background.

4 A damp sponge may be worked over parts of the montage. Doing this will take some experimentation as it may remove color. (This also depends on how the photo was printed.)

5 When the montage is completed and dried, the children can apply a coat of thinned glue, which will let the montage become clear and hard. Several coats of thinned glue over several days may be needed.

6 To frame the montage, duct tape can be adhered to each edge. Place the tape partly over an image and fold the tape to the other side.

School-Age Children:
What Does Art Look Like in an
After-School Program?

Sylvia works in an after-school program for a few hours every day. When the school-agers arrive at her door, they are either bouncing off the walls or exhausted. Since the children are there only a few hours each day, she usually just lets them chill out, but her administrator has asked her to offer some open-ended art activities. Sylvia asks, "Why bother with creative art when they seem happy with coloring sheets? We don't have time for anything else!"

By the time children reach school age, they typically have specific time each week to learn new techniques during the scheduled school day with a trained art teacher. If the children enjoy the formal art classes, then why not let them continue their exploration after school? The variety of after-school programs is wide, and the spaces they are offered in are typically shared. This chapter highlights some of the barriers to open-ended art in after-school programs and provides solutions that encourage creative art, even with limited time and space.

What Is Happening Developmentally

School-age children—children ages five to eight years old—begin to shift some of their focus from family to school and friends. They are moving from one stage of Jean Piaget's cognitive development theory to another. Around seven years old, many children begin shifting to what Piaget called the concrete operational stage. This stage is characterized by the beginning of logical thinking. Children begin to work problems out in their heads as opposed to needing to physically experience or try things. School-agers may gain knowledge, skills, and dispositions by reading, talking, or acting things out, which is different from preschoolers' need to interact with people, places, and objects. School-agers' logical thinking does not happen exactly when children turn seven; most children gradually begin to think logically based on their experiences. During the concrete operational stage, school-agers begin to understand that something may stay the same even though its appearance changes. This is the basic idea of conservation.

Piaget assumed that all children will pass through the stages of cognitive development, even though each child will do so at their own rate. Precisely when individual children reach each stage is fluid, and teachers recognize this when they account for individual children's differences through the different materials, activities, and expectations they provide. The developmental difference between children who enter a school-age program at around age five or six and those who are in the program at age ten or eleven can be huge. It's a difference that can present special challenges for school-age programs as they develop activities to meet the varied needs of the school-agers in their care.

games, books, and puzzles that support continued learning about art and artists. It is important for teachers to know the school-agers in their care. Each child, and the group, has developmental strengths, needs, and interests, and the parents have varying expectations. Consideration of all these variables will help teachers make decisions concerning what art materials and art-making opportunities should be available.

School-age programs should also consider the integration of technology and art. Many states include media arts or digital literacy in their standards for school-age children. Digital cameras, smartphones, and tablets allow children to create images, books, flyers, and many other digital-based products. These digital devices can also be used to document what others are doing through photography. Digital microscopes offer opportunities to study nature and create with the resulting images.

When using applications or software for digital devices, there are many sources that describe and evaluate software. Two worthwhile sources on technology and digital media in early childhood are the Erikson Institute's Technology in Early Childhood Center and the Fred Rogers Center (FRC) for Early Learning and Children's Media at Saint Vincent College. The latter organization produced a joint position statement with NAEYC called *Technology and Interactive Media as Tools in Early Childhood Programs Serving Children from Birth through Age 8*, which provides guidance for evaluating and using digital media that goes beyond coloring created screenshots, similar to coloring books, that encourage children to engage in digital art creation (NAEYC and FRC 2012). Additionally, there are many blogs, forums, and Pinterest sites that discuss early childhood technology issues.

Art Appreciation

Art appreciation can also be promoted in after-school programs. Technology is one medium to use for art appreciation. Online games and books can be used to integrate art in an after-school program. Games and videos may provide a change of pace and a sense of control; after all, children have spent four to six hours in an environment where many choices were controlled. Museums make the integration of art easier with web-based resources for teachers that often include virtual field trips or games. The Smithsonian Institution offers "Fun Stuff for Kids Online," which includes animal cams and games based on the various Smithsonian Institution museums. The National Gallery of Art similarly offers a variety of games and activities based on its collection. The Albright-Knox Art Gallery offers ArtGames 2.0, an app that allows students to interact with virtual worlds based on modern art. This museum stresses learning about modern art and visual literacy. Teachers should always check the sites to ensure they will work with the program's computers (for instance, you may need to install a program) and that the content is appropriate for the children involved.

Games can also provide an interactive way for children to learn about and appreciate art. Many boards games are designed for older children, but there is a series of "Go Fish" card decks based on Renaissance artists, Impressionists artists, modern artists, and others. "Go Fish" and a variety of memory games can be played with these decks. Children could be encouraged to create their own decks of art cards using colored printouts or postcards. There is also a series of activity books, *Spot the Difference: Art Masterpiece Mysteries*, that children can use to play versions of I spy. These materials can be used independently by the children or in pairs or small groups. These materials provide instructions for games or activities, and they also encourage children to create their own versions of games.

Biographies about artists can offer some insight into how and why an artist chose to make art. *Action Jackson*, a Robert F. Sibert Informational Honor Book, follows Jackson Pollock as he begins the two-month process of creating one of his most famous works, *Lavender Mist*. Children will find the prose and illustrations engaging and enjoy Pollock's technique, which included splattering paint. Learning how an artist creates a work of art over a period of time can provide lessons on problem solving and persistence. This type of book may inspire children to try this type of art making, or offer the after-school group the opportunity to use this type of art as the focus of an activity.

Opportunities for Longer Days

While time and space create many barriers to creative art for after-school programs, many teachers have the opportunity to expand the art activities during holiday breaks and summer vacation, when school-agers are in the program for longer periods of time. Homework is no longer a priority, and teachers have an opportunity to be creative and develop more detailed activities. The full days offer a great opportunity for teachers to develop art themes, and to plan the art activities using the curriculum, instruction, and assessment cycle discussed in previous chapters. While the school-agers would enjoy crafts such as beaded necklaces and coloring, think of all the amazing things that can be offered to them to reinforce and extend their learning.

Other Considerations

As mentioned earlier in this chapter, school-age children should have opportunities to engage in art media that requires greater ability, including fine-motor, organizational, and long-term planning skills. They want to participate in and try art that differs from what younger children are doing. These students may be exposed to STEAM (science, technology, engineering, art, and mathematics) during their school day. STEAM connects these content areas and encourages children to develop projects and ideas that integrate the do-it-yourself or maker movement. Doing STEM activities in school may increase their desire to explore art materials and techniques that develop new skills and apply them to STEAM projects.

Textile materials and textile-related skills, such as weaving, sewing, or fabric sculpturing, may be motivating to school-age children. Textile skills can be used to create art by varying the materials and the way the children use them. Weaving in particular has a long history; older civilizations used weaving to create cloth or rugs using animal fur or grasses to create baskets and other containers. Using a variety of fabrics, ribbons, and other materials, children can create artistic weavings or installations.

Weaving requires something to act as a loom. Lots of household or found materials can be recycled to use as a loom. The loom needs to have holes or spaces that fabric, ribbon, yarn, or other long material pieces can be woven into. Looking around a kitchen, you may notice an inexpensive sink mat or an inexpensive plastic basket that a child could use as a loom. Some fruits and vegetables are packed in netlike material that could be used. Looms could also be

created from found objects. Cardboard circles or other shapes can be used as looms by notching cuts and adding string to create the base, where ribbons of materials can be woven over, under, over, under. Other objects that may inspire loom creations may include sticks, or fences with holes or spaces to create large weavings, trees that stand close together, or climbing poles on a playground structure. Large looms may encourage collaborative art creations.

Providing a variety of long ribbonlike material will encourage children to experiment. Yarn, fabric, and ribbons are traditional weaving materials, and they come in all sorts of colors, textures, and sizes that can be inspiring. Challenge children to think of other types of materials that might work. Garlands in neutral colors, plastic webbing, narrow strips of Bubble Wrap, rope, and grass may provide some starting points. Think about the children's developmental needs and abilities ahead of time as you consider safety concerns. Look at images of artwork by contemporary weavers for additional inspiration.

Sewing can be used to create clothing or simple household items, and it can be used to create artist stitching or fabric sculptures. Children engage in activities that are similar to sewing when they string beads or use lacing cards. Around four years old, children can use real needles. Putting a piece of fabric in a frame, such as a small embroidery hoop, will hold the fabric in place as a child learns to pull a needle and thread in and out of the fabric to create stitches. Use large embroidery needles and allow the child to practice making stitches. Their pieces may or may not end up as art.

Children usually want to make something when they first begin using thread and needles. One entire Head Start class created their own nap pillows. Children chose the fabric and shape they wanted to create. Adult volunteers threaded needles and guided the children. Afterward, lacing cards and sewing were popular classroom activities.

School-age children can research various ways artists create pictures or sculptures before sewing art. Providing a variety of fabrics, ribbons, decorative items such as pom-poms, buttons, and fabric flowers can inspire fabric art. Some children may want to use yarn or embroidery floss for stitching with different textures. Stuffing material can also be provided to allow children to explore ways of adding dimension to the art creation. Children may appreciate embroidery hoops, stretchers, or other types of frames to keep the base fabric in place. Felt squares, burlap or jute sacks, or cloth rice bags would provide interesting bases. By age seven or eight, children can begin to use sewing machines to make simple items such as pajama pants or pillows with adult help.

Weaving and sewing can provide opportunities for school-age children to learn new skills or processes and to develop long-range projects. The skills involved could be used for individual creations or to plan and create large collaborative art creations. Traditional fiber materials such as fabric or yarn can be used, but both processes allow the possibility of incorporating nontraditional fibers and even some technology. Think of a small LED light and battery being added to an art creation.

As children have more exposure to STEAM in schools and their lives, they will want to integrate technology into their art. This integration could take place through the tools or material used as children explore the contents and art.

Personal Reflection and Practice

Prepare: One suggestion in this chapter is to provide children with the opportunity to visit art museum websites and play games. Locate two to three art museums that have a kids' page or online game section. Ideally locate art museums near your center or school, or one that has a collection on a topic that interests your school-agers.

Act: Take time to play with the games and materials on the websites. Note which sites are easy to use and which provide challenges for various age groups. Also note what type of games and art are present on each site.

Reflect: Think about the school-agers in your setting. (If you're not working with school-age children, you can consider another age group.) Based on your knowledge of the school-agers, which sites will you introduce and promote? How will you introduce the sites? How will you evaluate the schoolagers' engagement with each site?

Sample Art Activities for School-Age Children

School-age children typically receive some art instruction and open-ended art activities during school. Providing chances to use favorite materials or opportunities to experiment during flexible after-school time may appeal to them.

A Hole Challenge

A hole or holes can serve as a source of inspiration for this activity. A variety of hole punches, colored construction paper, and glue or tape are the only materials you'll need. This can easily be varied by using different drawing tools, cutting the paper in different shapes, or gluing the hole-filled paper on top of another sheet of paper (one that is a different color, tissue paper, or a magazine page, and so on).

1 Prepare several sheets of paper with holes. There could be a single hole or several. Different-sized holes can be produced by using hole punches, an e-hole punch, stencils, or other hole making devices.

2 Using the holes as a focal point, encourage the children to draw something around the hole as they see fit. For example, the holes may become the wide eyes of an alligator or the links on a dog collar.

Big Shape Art

Many favorite early childhood illustrators emphasize the use of large shapes. Some of our favorites are Eric Carle, Lois Ehlert, and Byron Barton. Materials for big shape art may include fabric scraps, buttons, stuffing, trim materials, and base fabrics such as felt, burlap, and so on.

1 After reading a book by one of the suggested illustrators, work with the children to examine and explore the illustrations.

2 Discuss how the selected illustrator uses shapes to create images, and work with the children to plan how they could use large shapes to create an object such as an animal, a vehicle, or a common household object.

3 As the children assemble their creations, they can add dimension to their creations by stuffing some shapes and adding trim, buttons, and so on.

4 Children could assemble their creations by sewing or gluing the pieces together.

Sensory Activities and Children with Special Needs: What Do I Need to Consider?

José notices Maria watching the other children at the art table. The children brush glue onto tissue paper and place it on construction paper, but Maria does not join in. José squats down next to Maria and asks if she would like to try using the glue and paper. She shakes her head no, watches a few more seconds, and walks away. Later in the day when José reviews his monthly anecdotal notes, he realizes Maria never engages with art materials. As he reviews his notes, he remembers several times when she became upset and screamed when an adult gave her art materials like paint or clay. José wonders how he'll encourage Maria when she doesn't seem to like to touch certain materials.

Often people joke that working in an early childhood classroom is like "herding cats" because the children are always moving in different directions. A group of children whose ages range within twelve months of one another can be at various developmental levels, and their families and communities can have varying expectations for behaviors and skills. While all children in early childhood classrooms have different abilities, most children will eagerly explore and use art

materials. When modeling dough is set out on a table or fresh paint is placed at an easel, most young children will gladly push, prod, and explore.

Occasionally children will object to using art materials or avoid the art area day after day. These children may object to the textures or smells of the materials. Other children may wish to engage with art materials but have difficulty using them. Sometimes children have not had experience with or exposure to art materials or tools and generally need opportunities to use the tools and materials. Other children may have perceptual or physical difficulties that may or may not have been identified. Their difficulties aren't related to their age but could be a developmental delay. Situations such as these can be challenging, but there are ways to overcome the barriers. This chapter explores how to engage all children in art through different methods and materials.

Why Do All Children Need Art?

Throughout this book we have presented reasons why open-ended art experiences are important. These discussions apply to all children, because all children need opportunities to express themselves with art materials. Each child has a viewpoint that reflects their experiences and perspectives. Start with what children *can* do, not what they can't.

Children in Ms. Beach's first-grade classroom were studying families. Each child was asked to use art materials to represent their family. Most children picked up drawing materials or paint and a sheet of construction paper. Celeste, a child in Ms. Beach's class, had difficulties holding the drawing tools due to a birth defect.

Ms. Beach spoke with Celeste about how she wanted to represent her family and offered her the opportunity to use other materials or technology for the activity. Celeste decided to use unit blocks and wooded cubes to create her family; she could manipulate the blocks herself. As her block family took shape, Celeste asked for assistance getting yarn, ribbon, and googly eyes. Another child helped her get the materials and placed them where Celeste directed. Looking at the figures, Celeste said, "No mouths," and looked about the room. She located thin black Legos and with help put these on the faces of her family members. Ms. Beach helped Celeste take pictures of her family with an iPad. When the class shared and discussed their representations the next day, Celeste shared the photos of her block family. Over the next several days, creating block families became a popular center time activity. Children used classroom digital cameras to record their creations. Ms. Beach began introducing the concept of sculptures to build upon the class's interests.

In this example, Ms. Beach thought about Celeste's needs and development as part of the planning process. She also thought about the learning outcome. In

this case, her outcome focused on representing families and identifying relationships while using various art media. Allowing children to choose the materials for their representation indicated a consideration of the group and the individual child's interests and needs while also supporting the learning outcome. Although many children chose drawing and painting materials, Celeste chose blocks so she could manipulate the materials herself. Another child who disliked drawing might have ripped and cut paper to create his family. All the children were engaged in the same activity with the same outcome but each was allowed to use materials they liked or could control. This is one way of planning that includes all children but allows choices.

Another example of accommodating all children is to require everyone to use the same materials but to offer some adaptations. In the example with Celeste, Ms. Beach could have required everyone to use crayons and colored pencils. Celeste would have needed an adaptive tool to accomplish the task. Because of their fine-motor coordination, other children may have needed pencil grips. Including all children means finding ways to adapt the materials or to allow flexibility of choice of materials so all children can participate.

Ms. Beach also considered assessment while planning her learning outcomes. In this case, Ms. Beach had the children present their representations while she quickly interviewed them. This allowed all children, including Celeste, to participate in the assessment process.

How Can I Help: Children Refusing to Do Art?

Teachers often discuss children who refuse to participate with art materials or activities. Children as young as toddlers may get upset, shake their heads to indicate no, or cry when presented with certain art materials, often sensory materials such as paint, or certain activities such as drawing or cutting. Behavior is a form of communication. When children refuse to participate in an activity or when they use materials in a dangerous or damaging way, they are telling something to the adults around them. When the child refuses to participate, the adult needs to consider possible feelings of anxiety, frustration, or boredom. The child's reaction needs to be observed and investigated to determine its source. Is it a sensory issue related to a special need? Is the child unsure of how to use the tool or material, or does the child lack the ability to use the tool or material, as would a child with under-developed fine-motor muscles? Perhaps drawing hurts and the child needs experiences that will strengthen their muscles. Take the time to observe, speak with parents, and if needed, work with parents on getting a disabilities screening.

If a child has been screened and is receiving services, speak to the family and any service providers. If possible, find out what the goals are on the Individual Family Service Plan (IFSP) or the Individual Education Plan (IEP). Understanding what the child's needs are and what the possibilities for accommodation are will help teachers adapt materials and activities for all children.

General Strategies: How Can I Include All Children?

All children have needs. Toddlers don't always have the language to express their wants or needs, preschoolers are usually egocentric and sometimes struggle with sharing, while infants generally put lots of objects in their mouths. General adaptations or modifications will support all children.

Many children with special needs have difficulty with organization. As discussed in chapter 2, think about how the environment can promote children's exploration and use of materials for creating art. Organization of the environment can support children with attention challenges too. Some children are easily distracted. For example, a child may go to the art area and grab a lot of stuff. Or a child may tell you, "I'm going to use clay," and then grabs the clay, tape, shiny paper, and pipe cleaners. Both of these children may be distracted by choices. Gathering too many materials, or not the ones needed for a specific task, can easily frustrate children.

One solution is to place like or related materials near each other. Put the scissors, glue, large sheets of paper, and collage materials near each other. Put the clay, mats to work on, and clay tools together on one shelf. Children are then less

likely to get distracted by various colors, textures, and the like and get the materials they want. Cleanup may be easier if materials are stored near each other.

In addition, the age of the children and their developmental levels should be considered. Some children need order to function well in an environment. They are helped by labels for materials and tools and predictable, consistent daily schedules. One teacher learned this the hard way. During the first week of school, she discovered all the bins of collage materials in her carefully organized art center had been dumped on the floor when she was busy in another area. This happened three days in a row until the teacher was so frustrated, she turned the shelf of art materials toward the wall and declared the art center closed. Her administrator gently reminded her that children have different needs, and this group's need was to dump materials. While it's important to provide a wide variety of materials, the materials need to be introduced slowly. For this group of children, the teacher and administrator decided to introduce just paper, glue, and one bin of art items at a time. The teacher observed the children, and as they learned to use the materials for art, she added more bins of collage materials. It took several weeks for the art center to be fully developed, but eventually it was successful.

Young children are not spatially aware. They are not good judges of how much space their bodies take up, or of how much room they need to go around people or objects. They are constantly bumping into other people and objects in the early childhood classroom, which leads to frustration, tears, and in some cases, tantrums. How would you feel if you spent hours decorating a cake and someone bumped it and messed it up? This is how children feel when someone touches or bumps their work, whether accidentally or on purpose.

Help children understand their work space and boundaries by preparing the environment. Provide small containers or baskets to collect the art materials needed for a project so children aren't juggling a pile of supplies or going back and forth several times to get their supplies. Dividing the art table or space into personal work areas may help children recognize individual boundaries. Catalogs, teacher supply stores, and art supply stores offer trays of various sizes that children may use as work spaces. Several teachers have described using tape to divide the surface of the art area table into separate work spaces (make sure the tape is removable and doesn't leave a residue on furniture). It is also important to help the children understand the purpose of any organizational materials (for instance, a basket for supplies) through explanation, modeling, and reminding.

There are many ways to support all children's art-making efforts through choices of materials that require different skill or strength levels. Think about the muscles and skills needed to open or operate the materials and tools. Providing glue sticks and white glue in plastic bottles allows two types of actions.

The white glue requires a child to twist the cap and squeeze to get the glue out, while a glue stick involves pulling off the cap and pushing glue through a cylinder. Different children may have success gluing with these different products. Other examples of choices that accommodate children's abilities include various sizes of pencils, crayons, and other drawing and writing utensils with pencil grips. Soft foam hair rollers or craft foam may work as writing utensil grips. For some children, wrapping tape on the pencils or crayons helps.

Teachers may want to consider materials' physical properties when adding them to the art center. Nicole Martin (2009) suggests using Vija Bergs Lusebrink's art materials continuum to assist in the determination of different children's responses to different materials. Vija Bergs Lusebrink, an art therapist, suggested a continuum for organizing materials for art therapy; Nicole Martin adapted this continuum for children with Autism spectrum disorder. Using Martin's interpretation, figures 2 and 3 below put common early childhood art materials on the continuum from fluid to rigid (2009, 72).

Figure 2. Selected Materials from Lusebrink's Continuum for Two-Dimensional Art:

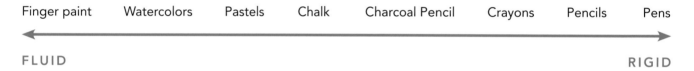

Figure 3. Selected Materials From Lusebrink's Continuum for Three-Dimensional Art

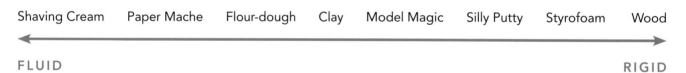

These continuums will assist teachers in thinking about a material's physical properties. Children who have less developed fine-motor skills will have more difficulty manipulating or using rigid materials. Other children may prefer more rigid materials because they don't like the feel or texture of the fluid materials. Families, and if a child is receiving services, the child's therapist, can help teachers figure out which materials work best with children who have sensory issues. It is important to remember that no child should be forced to participate in an art activity or center; alternatives should always be available.

Some children do not want to participate in the art center or with art materials because they dislike getting messy. This may be due to a sensory issue, a personal preference, or even a family's rule. Checking on what might be preventing a child from participating is important. If the child is afraid of messiness, reinforcing the cleanup options may help. Sharing information about the program's expectations and examples of daily activities at intake will increase families' understanding of the program and the use of messy materials. Helping families understand how creating art and using tools like paintbrushes promote the skills and muscles needed for reading and writing may help families compromise on their "no messy materials" preferences. Children who are sensory sensitive or who do not want to get messy may like to cover their clothes with old shirts (cut to a child's size) or smocks. These children may also like to wear rubber gloves. It is important to ensure that the clothes and gloves fit a child and don't impede their movement; also check to be sure a child doesn't have rubber allergies. Paintbrushes come with various types of handles, and so do scissors. There are many low-tech, low-cost solutions to be found on the internet.

Many young children have difficulty marking paper and drawing on flat surfaces; the material moves as the child tries to draw, paint, or engage in other techniques. Having clipboards or tape to hold down paper is one solution for this challenge. Allowing easels to be used for creating art other than paintings will also help. If possible, invest in or make tabletop easels (they can be made out of boxes). Slant desks may also be an option.

Children with special needs often have weaker fine-motor muscles. It is important to plan activities or include materials that will help develop fine-motor skills. Picking up cotton balls, pom-poms, and so on requires children to use their pincher grip. Providing soft dough and eventually clay helps children use different muscles and art techniques. It is also important to provide adaptive tools as needed. Children who receive services may be entitled to adaptive tools, and service providers can generally assist with obtaining them.

How Do I Start?

Once the environment and materials have been reviewed, you may wonder, "Okay, how do I start?" You may need to build children's experiences with sensory explorations or creating art by building on the child's experiences with materials and/or tools. Children could be preschoolers and not have had experiences creating art or using certain materials. Some teachers assume none of the children has ever created art or used art materials or tools, and they regularly introduce art items to the children as new.

Teachers can introduce art items as new through a demonstration involving a child, through the teacher's modeling what to do, or through other creative ways.

One teacher used a puppet, Artie, to introduce materials, techniques, and ideas. Artie did not often know the name of many of the art objects or how to use them. For example, when introducing painting combs, Artie would ask, "I wonder what you do with this?" As the children suggested ideas, such as "You comb with it," Artie would do the action. The children thought Artie was silly, and they were comfortable correcting Artie's mistakes. The teacher would eventually help Artie

figure out the real purpose of a tool or material. This provided the group with information in an engaging, age-appropriate manner rather than focusing on certain children who needed extra instruction. Using the puppet served a purpose and helped make this setting an environment where all the children were comfortable.

There are many ways children with sensory issues can engage in art making without touching the glue, paint, or other upsetting materials. Matt, a teacher of young preschoolers, encouraged the children to observe and interact with nature. Matt's love of the outdoors influenced his classroom routines. He regularly took his class on nature walks in a nearby park or on a neighborhood walking trail. One child in the class, Joey, was identified as being on the autism spectrum. Joey had a sensitivity to various textures, including paint and glue. Joey often became very agitated in the art center or if the boys he liked to play with engaged in creating art. Matt wanted Joey to become more comfortable with the art center and to have an expressive outlet.

On one nature walk, Matt and the children collected sticks. Upon returning to the room, some children gently rinsed their sticks. After the sticks dried, Matt placed some of the sticks in a couple of clear containers in the art center. He also added a couple of trays in the center. One morning Matt placed the trays and containers of sticks on the art center table. He placed three sticks diagonally on the tray. During the morning circle, Matt read a book about sticks, and over the next few days, Matt reread the book. Matt noticed children arranging the sticks on the trays. Matt often used his smartphone to take photos of the children's work, so it was natural that the children asked Matt to "take a picture of my stick art." Children began to bring sticks in from home. Throughout the week, Matt noticed Joey arranging sticks when his friends were in the art center. One day, Joey tugged on Matt, asking him to take a picture. "I made art," Joey said.

Not every child entering your setting or classroom has had the same experiences. Some children may need to make art with objects such as shells,

pinecones, leaves, or other natural materials rather than using more traditional creative materials such as paint and glue. Collections of interesting objects, especially natural materials, can be used by children. Children can arrange materials on a surface, such as a large felt circle, a slab of wood, or a child-safe mirror. After the child is done, a digital photo can be taken, thereby preserving the child's art making.

Some parents provide opportunities for their children to engage in lots of sensory and messy experiences before the child begins Head Start, child care, or school, while other parents do not allow these experiences. Children's preferences for and knowledge of materials and their uses may be the result of cultural expectations (for example, children shouldn't look messy), a parent's bad experience with trying messy art materials, or a parent's not being aware of the developmental benefits of children engaging with art materials or experiences. A five-year-old with weak fine-motor muscles may not have a disability.

It's possible this child simply hasn't had experiences with dough or scissors. A parent once told his child's kindergarten teacher that the child, Aaron, had never used crayons. The parent explained that Aaron drew on the walls when he used crayons at eighteen months. Upset with the mess Aaron had made, the parents never allowed him to use crayons again. Once Aaron began engaging in various fine-motor activities at school, and practicing with dough at home, he quickly began to develop his muscles, eventually handling crayons and pencils like a pro.

Although children may have special needs, it is important that all children gain foundational art skills. Foundational skills, such as how to use scissors or paint or how to do a specific painting technique, can serve as the basis for self-directed, original art. Foundational skills can be taught through a wide variety of scaffolded activities. While teachers may be inclined to develop a craft project that requires everyone in the class to work on a specific skill, such as cutting, these skills can also be encouraged through open-ended experiences. There is no need to give children worksheets with dotted lines to cut if they are inspired to snip brightly colored yarn into spaghetti noodles or cut the long wavy hair of a monster from paper.

Another way to encourage children to engage in the art center is to provide a provocation. A provocation is a suggestion or idea that is used to inspire an idea, discussion, or interest. Provocations are inspired by the Reggio Emilia approach. The provocation, often a new art display or item, will provoke children into thinking about art by encouraging questions, discussion, creativity, or another such reaction. Educators thoughtfully provide an idea starter and then allow the children to develop a project, idea, art, or other means of acting on the provocation.

An art provocation could be a material placed beside a photograph or image of a sculpture. It could be old art materials displayed in a different way or in a new, unexpected combination. Perhaps a teacher knows that Sydney, a girl who typically avoids art materials, loves rocks. Sydney often collects rocks in her pocket and knows many facts about rocks. A provocation aimed at getting Sydney interested in the art center may include displaying a couple of photographs of rock sculptures, artfully arranging some rocks on a piece of fabric, and placing some science magazines featuring rocks on the art center table. Someone is bound to tell Sydney to look in the art center. Sydney may choose to ignore this provocation or she may engage with it in some way. The outcome isn't predetermined, but the idea is to get the child involved in something different, such as the art center. This may seem like a small step, but it might encourage the child to touch or engage with new materials.

Art Appreciation: The Same but Different

Art appreciation is another way of getting children with special needs involved with art. There are many ways to use books, images, and online sources to encourage art appreciation. It is important for all children to view themselves as capable of creating art. This is especially true as children become older and understand they each have different capabilities. Teachers can use the internet to search for artists that have the same disability as a child in the class may have. Displaying images of these artists and their work, and discussing these artists, provides a role model for children with special needs. Including information about artists with special needs also helps children with typical needs understand that disabilities are not limiting.

Personal Reflection and Practice

Prepare: Think about something you hate to look at or touch. One teacher gets upset by images of snakes, and another dislikes the texture of cotton balls and chalk. None of these things should be upsetting; after all, images of snakes are not real snakes, and cotton balls are harmless, yet the teachers involved can still feel upset.

Act: Imagine you had to touch the image or object you find upsetting. You had to use pictures of snakes or actual cotton balls in your art creation. The administrator or principal has stated you will be in trouble if you don't touch the upsetting item. What if not touching the item could result in getting yelled at, getting a poor evaluation, or getting fired?

Reflect: Think about how unpleasant materials could be changed or adapted. The administrator offers tongs or a scoop so you don't need to touch the cotton balls. She makes different materials available, such as pom-poms or a choice of reptile pictures or stickers. How do choices make you feel? Think about how you can apply this exercise to your room or setting.

PART 3

Finding New and Different Techniques

JUNE 2017 23

Strategies and Techniques: Where Do I Find Something New and Different to Use in the Classroom?

Antonia has been working as a teacher for some time in a child care program where she fills in for several different teachers, but she feels like all the classes are doing the same kind of projects all the time. She says to her administrator, "I'm tired of the same old projects. What can we do that's different and sets us apart from other programs?"

Many programs already have a lot of great options available in the art center, but as the children grow and develop, they need to be challenged. Placing a piece of paper in a shoebox and adding a squirt of paint and a few marbles to make a marble painting is a great place to start, but rolling marbles inside a box over and over offers children very little opportunity for growth after the first few experiences.

As children begin to master the basic skills of cutting, gluing, and maneuvering a paint brush, they have a greater desire to make a project that looks like something. They want to move beyond painting at the easel with fat brushes and focus on more challenging techniques. Children's desire to grow provides a great opportunity for teachers to integrate new techniques and styles. Take some time to learn a new technique yourself and share what you learn with the children. Keep in mind that the focus is not what the children should make, but how they should use the new medium or technique. Previous chapters provided detailed instructions for art activities, including the materials and the steps for each one. Now advanced strategies and techniques, such as collage, inkblots, and modeling clay, will be introduced, but it's up to you to determine the appropriate materials and process based on the children in your program.

Strategies for Collage

Anything that is glued or pasted onto something else could be considered a collage. Children love collage because it allows them to experiment and play with the materials without having to make a commitment to a brushstroke. They can glue something down, move it to a new spot, or cover it completely based on how it looks and feels as their project comes together. Teachers may notice that toddlers find tremendous satisfaction in gluing one item on top of another item until they have a three-dimensional stack, but then pull each item off one by one.

As the art center is being developed, encourage children to collage by leaving a variety of materials, paper, and glue in the art center. Items such as stickers, scrap paper, foam pieces, and googly eyes provide a great foundation. Older infants and toddlers may simply use the scraps in whatever form they find them in, but they will gladly rip a large piece into smaller pieces with some encouragement. By the time they are two or three years old, children begin to prefer the scissors as they gain fine-motor skills and the ability to create finer shapes and designs. While popular items should remain, other items can be rotated based on topic, theme, or interest. Over time, new techniques can be introduced to provide richer experiences. Teacher supply catalogs will offer some ideas, but the collage materials can be expanded by adding used and recycled items such as wallpaper, string, puzzle pieces, or the coupon section of the newspaper.

Be thoughtful of the diversity represented in your materials. Be sure to include paper, crayons, and paint that represent many different skin tones. Additionally, the magazines that are offered for scrap should reflect diversity in many different forms: culture, age, gender, ability, and interests, just to name a few. The magazines you likely have around your house are a fine place to start. Then visit your local grocery store and browse the magazine racks for more options. What about *National Geographic Kids*, *Mocha Kid Magazine*, *KoreAm Journal*, *Catster*, *Cooking Light Magazine*, or *Southern Living*? Think about how each magazine is produced for a specific audience with very different images. With a little effort, you can gather a wide variety of diverse options for the children to explore and cut. At the same time, be sure to avoid magazines that may have inappropriate images or articles, including those that emphasize popular culture and celebrities. Families may also have magazines and newspapers they can contribute.

Once the children have had time to explore and use basic collage materials in the art center, it's time to introduce more advanced techniques. Start with the paper that is provided. Children can glue the materials to construction paper, but think about all the different materials that can serve as the foundation for collage: wallpaper, cardboard, tinfoil, and even fabric or pieces of wood or bark.

As they reach the preschool classroom, children may be ready for more inspiration. When appropriate, teachers can begin to introduce more specific collage techniques. This does not mean there is formal instruction, or that everyone is expected to complete the same collage activity at the same time. It means teachers introduce a new technique to the children, either as a large or small group, and then leave the materials in the art center for further exploration. Teachers may provide a model, but the model provides an open-ended example of the technique, not a model the children are expected to copy. The following options are offered as opportunities to challenge the children to think differently about the collage materials they use.

Paper versus Fabric Collage

Paper is a simple addition to collage because young children can cut, crinkle, shred, and tear it. Fabric provides a new and different experience, because it can be folded, trimmed, and glued in unique ways. If you choose to add fabric, then be sure to offer fabric scissors for cutting to minimize frustration, or precut some of the fabric into smaller, manageable pieces. Faith Ringgold, author of many children's books, including *Cassie's Colorful Day* and *Tar Beach,* combines her African heritage and artistic traditions with her artistic training to create paintings, multimedia soft sculptures, and "story quilts." Her artwork could serve as a model to provide inspiration to children as they begin to work with fabric.

Thematic Magazine Collage

In small groups, encourage the children to explore a theme. Provide magazines and encourage them to find pictures related to the theme and to organize them. The children can work individually, in pairs, or as a small group. This is when it becomes useful to collect related magazines. For example, *Catster* will be interesting if the children are exploring the topic of animals, pets, or cats, while *Cooking Light Magazine* may inspire a collage around food and nutrition. Work with children's families and community partners to find a wide variety of age-appropriate magazines.

Family Collage

Developing a theme of families provides a great opportunity for families to participate in daily activities. Encourage each family to send in pictures, stories, or words that children can use to create a banner representing their family. They may select a Jamaican flag to indicate their heritage, pictures of camping to represent a favorite family activity, or recipes of favorite foods that represents their culture. Each child can develop their own page, and the teacher can attach and display the pages in the form of a family quilt. The family collage project can also be completed at home and returned to school, but please be sure families have the necessary tools, such as scissors, construction paper, and glue.

Monochromatic Collage

Children enjoy sorting items by color. For a monochromatic collage, children select a color and sort a variety of materials that show a full value range (from light to dark) and different intensities (from bright to dull) of that color. If each child in a small group works on a different color, then the group can help sort the materials into piles for their friends. For example, one child may collect greens, while another child may collect shades of red. Once they have their piles sorted, children can work to glue their colors together into a collage.

Self-Portrait Collage

Ask the children to go through magazines or other collage materials to develop a collage that represents themselves. What objects do they select to represent themselves and their identity? They may select words, pictures of their favorite things, colors, or specific parts of different pictures to create a face. Young children may need prompts to help them understand what to look for (such as encouraging them to find a favorite food), but older children are likely to find a creative combination of items for their self-portrait. These individual collages could be attached to create a large classroom quilt, or the teacher could punch holes in each picture and bind them together with string to make a special classroom book.

Strategies for Three-Dimensional Collage

We've already gathered a collection of collage materials. Now look for items that have some depth or height, such as buttons, wooden craft sticks, and pom-poms. Any of these items can be glued to paper to create three-dimensional artwork. Providing a base, such as a ball of clay or dough, allows children to create something different with a new effect. Changing the collage materials or focus of the collage technique can refresh the children's interest in art making. Manipulating paper and paper products to create three-dimensional effects (that is, building up instead of across the paper) can offer additional challenges, work on additional skills, and provide problem-solving opportunities. Three-dimensional materials such as wood pieces, dried flowers, and pipe cleaners offer more options. The following activities could be introduced to a large or small group, with the materials left in the art center for the children to explore.

3-D Paper Collage

Provide children with strips of paper and ask, "I wonder how I can make the paper stand up?" Children will need to experiment with crumpling, stacking, and eventually bending the ends to create an arch or spring. Provide an example, such as a greeting card where a piece pops out when the card is opened, or read a favorite pop-up book. You can also show the children how to fold strips of paper into a zigzag pattern. You could say to the children, "I'd like to make a silly monster. How could I make these button eyes pop off the paper?"

Cardboard Relief Collage

Layering different shapes and textures of cardboard can create a very interesting three-dimensional effect. Some cardboard can be hard to cut, so this may work better with confident cutters or with thin cardboard. The teacher can also cut some cardboard pieces in advance. Encourage the children to develop a collage idea, and then problem solve how to layer the cardboard to accomplish the goal.

Cardboard Sculpture Collage

Many people tend to work flat across a piece of paper, but children can find ways to manipulate cardboard upward into a three-dimensional design. Charles Biederman (1906–2004) was a constructivist sculptor. He used paint and aluminum foil to create reliefs, and pieces of wood or aluminum to create three-dimensional images. His work can be viewed at the Metropolitan Museum of Art website. To create this type of sculpture, follow these simple steps:

1 Show children how to fold stiff paper or cardboard. If using plain cardboard, the children may want to paint it first.

2 Stand the cardboard pieces on paper.

3 Move the cardboard pieces around trying different designs, patterns, and arrangements.

4 Once satisfied with the look achieved, glue the edges of the cardboard to the paper.

5 For a different look, experiment with old playing cards, puzzle pieces, collector cards, or postcards.

Strategies for Inkblots

Inkblots are created when ink is splattered on paper and then, through a variety of techniques, spread or moved around the paper to create a design. Margaret Peot (2011), an artist, writer, and teacher, defined many ways to encourage artists to be creative through inkblots. Ink and paper are fairly inexpensive, so they are a simple addition to any classroom.

Ink is permanent and requires careful use, but a creative teacher can find ways to do the inkblot approach with children through their careful use of smocks to protect clothing. The activity may emphasize a certain skill, and close supervision is required with ink, but the final products will vary greatly as the children move the ink around the paper in different ways. Many teachers have children follow a simplified version of the inkblot technique by placing tempera paint on paper instead of ink. The children then fold the paper in the middle to create shapes such as butterflies, vases, or abstract patterns.

Colored tempera paint and other paint materials can be substituted for a different effect. Ink on white paper creates contrast, but colored paper can also be used. Inkblots create unique and open-ended experiences because every inkblot is unique and can tell a different story. Of course, an experienced artist may work toward creating a specific inkblot design.

Splatter Paint

As a starting place, the children can dip a small brush in ink and "flick" the brush toward the paper to create a splatter effect. Have the children try to cut out a specific shape, such as a star or a heart (or cut the shape out for them), place it on the paper, and then spatter ink over the entire paper. Let it dry for a moment, then pick up the shape to see the design that was left behind. The white space left behind is called a negative space. Selecting different types of paper and adding differing ratios of water to the ink will create different effects.

Drop Paint

Similar to the splatter paint, children can use a variety of tools to create different effects with the ink. Try different-sized brushes or eyedroppers and encourage the children to drip small amounts of ink onto the paper. The dark spaces created by the ink are called the positive spaces. Depending on the intended effect, the paper can be left open or folded in half for a symmetrical picture. Selecting different types of paper and adding differing ratios of water to the ink will create different effects.

Blown Paint

Once children know the difference between sucking and blowing air through a straw, they can be taught how to blow the ink around the paper to form a design. Place a good-sized drop of ink on a piece of paper. Using a straw, have the children blow the ink and watch it move across the paper. Encourage them to observe as different shapes and forms begin to emerge.

Inkblot Appreciation

As children create their projects, take time to observe and ask questions about their work. The following questions can be asked as part of a small group activity, or individually as children work.

Margaret Peot (2011, 35) offers the following ten tips for looking at an inkblot:

1 Look at the positive shapes—the ones made by the ink and water.

2 Look at the negative shapes—the white spaces around and between the shapes made by the ink and water.

3 What is the action like in the inkblot? Is it fast and splashy? Slow and trickly?

4 Is this a heavy inkblot or a light one? Is it cloudlike or as dense as lead?

5 Is this a secret picture or a billboard for everyone to see?

6 Do you see two things side by side or facing each other or one thing facing you?

7 Where is this inkblot? Does it look as if it could be in water? In the air? Buried deep underground?

8 Is the inkblot loud or quiet?

9 Is this inkblot hot or cold?

10 Turn the inkblot upside down and try these questions again.

Some of this vocabulary will probably be new to the children. Continue to ask questions as children experiment with different techniques to encourage their use.

Strategies for Modeling Dough and Clay

Modeling dough is commonly used as a sensory activity, and many recipes for variations of modeling dough are available. Teachers can whip up a batch in their kitchen with household staples such as flour, sugar, salt, and cornstarch, and they can add a variety of colors and textures. Working the dough into different shapes offers children a relaxing experience, and when used with caution, the addition of essential oils, such as lavender or cedarwood, can provide a calming aroma. Modeling dough is great for toddlers because it is very soft and perfect for little fingers. When it dries, it's easy to clean up, and a wide variety of toys and tools can be used to manipulate the dough. The children can pinch and pull the playdough into different shapes and designs and then roll it back up when they are finished or leave it out to air dry. From playdough to moon dough, or salt dough to slime, the dough options for the children to experience are many.

As fine-motor skills develop, children become ready for new challenges. Modeling clay is great for older children, because it is firmer and holds a form better, plus it doesn't dry out or crumble. It is available in a wide variety of colors. Real clay is natural because it comes from the earth. As the children work the clay, it can be moistened with water until it gets softer and slipperier and the right consistency to mold. It will harden and become stiff as it dries. Natural clay can be kiln dried, but that's not a necessary step if the natural clay is used as art. The children can paint the natural clay once it's dry using tempera paint, or they can add accents, such as feathers, beads, or other collage materials.

Artists use a lot of different tools to mold and work the clay. There is no need to purchase expensive tools for use in the classroom, the children can experiment

with items such as rolling pins, plastic forks and knives, and household items that make holes, shapes, and patterns in the clay. Some children may be interested in locating directions or videos that show them how to make striped clay pieces, a clay bull's-eye design, or other clay shapes by using multiple colors of clay. Many simple ideas for variations are available online once the children have gained some experience.

Let's think about how a new clay activity may be introduced to a young group of school-age children. At the beginning of an activity, it's helpful to prompt the children with an introduction to the materials and a representation of something that could be made. Discuss cleanup strategies too. Ideally the children have already had plenty of opportunity to manipulate clay, but a review and discussion of the medium helps ensure that everyone is ready to work.

When it's time to introduce the representation, think about what the children know and understand about the object. For example, if you have been working through a theme or topic that includes plants, you could introduce a flower, or a few varieties of flowers. You could ask the children what they notice about the flower or flowers, what is similar and different about the flowers. You could draw attention to the parts of the flowers and compare the different shapes of the petals.

When it appears that everyone is ready, you could introduce the project like this: "It's time to make your own representation of a flower out of clay. Close your eyes and think about how your flower might look. Don't start yet. Close your eyes and take a deep breath. Your lovely flower is already inside you. All you have to do is let it come out. That's what we're going to do with our modeling clay this morning. We're going to make our own flowers, each one individual and unique."

At this point, many children are likely to rush into the project, so it's important to work with them to encourage them to take their time. You may draw attention to the child who is still deep in thought or working slowly. Neatness is not a priority; instead emphasize the design and style that go into a project, one that has character or personality. It takes time to work with clay, so it may take several days or lessons for the children to figure out how to stretch and mold it into their final project. Play quiet background music and encourage the children to work quietly and think about their process. When they are finished, be

sure to arrange the sculptures in an inviting display. Use felt or fabric as a back-drop, add some folded paper labels with the artist's name, and make it a display worthy of the children's time and effort.

Basic Clay Techniques

Young children will enjoy a wide variety of basic techniques. Clay can be shaped and molded, rolled and cut with scissors, and stamped and pressed. Different tools can be offered to create different designs. As discussed above, things such as beads, shells, and other natural items can be offered as embellishments.

Clay Representation

All children can be encouraged to observe an item and represent it through clay. Teachers may highlight the long neck of a giraffe, the large ears of an elephant, or the flowing tail of a horse. Through trial and error, the children can experiment with different ways to represent what they notice.

Pinch Pots

Small pinch pots are common because they are fairly simple for children to make. Select a clay that can air dry, and work with the children to roll their lump of clay into a long worm. Starting with what will be the base of the pot, wind the worm around and around in a circle until a pot begins to take form. Show the children how to pinch the worm to close all the gaps and create a smooth finish. When they are satisfied, let the pot air-dry for several days.

Strategies for Crayons

Every classroom has crayons available because crayons are nontoxic, inexpensive, and available in a wide variety of colors. Whether brand new or broken into pieces, they can be used in a number of different ways.

ACTIVITIES FOR PRACTICE

Crayon Cookies

If you have a lot of broken crayons, crayon cookies are a great option for reuse. With the children, peel off the crayon wrappers, break the crayons into smaller pieces, and sort the pieces by color into a small or large muffin tin. Use an old tin; after making the crayon cookies, you won't want to use the tin for food. Preheat an oven to 250 degrees and place the tin in the oven. Watch the crayon pieces closely until they melt, about ten minutes. Take the tin out of the oven and let it cool.

Crayon Resist

Have children create a drawing with crayons that are made of wax or with oil pastels; these will resist water. After creating any image on paper with the wax crayon or oil pastel, use a watercolor wash to create an interesting effect. A watercolor wash requires using watercolors thinned by water and then painting over the entire drawing. Experiment with the paint colors. What happens if the picture is washed with a light-colored paint? Or a dark-colored paint? What if a picture is drawn using only one or two crayon colors and then it is washed?

Crackle Crayon Drawings

As children examine images of very old paintings, they may notice cracks in the paint that develop from age. Children can experiment with creating crackle drawings. Follow these simple steps:

1 Have children draw a face or other image on a piece of paper and then color it with a thick or heavy coverage.

2 Crumple the drawing into a ball by squeezing or twisting it gently. Carefully open the drawing. There will be lots of wrinkles.

3 Apply a thin black wash over the drawing. (Create a thin wash by dabbing a paint brush in water and mixing it into the watercolor paint. A dark color other than black can also be used.)

4 Let the painting dry.

5 After drying, paint a thin coat of thinned white glue over entire picture. This will provide a little bit of a shine to the picture.

Strategies for Working with Household Materials

Many household items, such as tissue paper, aluminum foil, and wrapping paper, can be used for creative projects. Children love wrapping paper because it reminds them of happy events and it comes in a variety of colors, themes, patterns, and textures. Usually inexpensive or free, household items are a great addition to any art center. Tape is an important addition, and masking tape now comes in a plethora of colors and patterns. As children grow older, it's useful to challenge them with new ways to use the materials.

ACTIVITIES FOR PRACTICE

Tissue Paper

Tissue paper has many uses because it is thin and easy to manipulate. It can be cut into squares or other shapes and layered on paper, or children can crumple it into balls and glue it onto a base for a three-dimensional effect. Eric Carle illustrated his children's books with tissue paper that was often "bled." This technique can be duplicated by placing the tissue paper on the base paper, applying water to the tissue paper with a paint brush, allow the "edges to bleed," and then remove the tissue paper. Liquid starch can also be used. Visit the Carle Museum for examples that can be shared with the children: www.carlemuseum.org/making-art-tags/tissue-paper-collage-0.

Aluminum Foil

Aluminum foil is popular because it is easy to manipulate. Children can color or paint directly on it to utilize the shiny texture, or they can cut it to create a design. Young children enjoy the feel of crumpling it into a ball or folding it into a long thin shape such as a snake. When crumpled, it can be added to a collage or a three-dimensional project.

Wrapping Paper

Wrapping paper makes an excellent addition to the collage items, but it can be used in large pieces for different projects. Search for neutral patterns and designs rather than cartoon characters or specific holidays motifs. Even the empty cardboard roll can serve a creative purpose.

Personal Reflection and Practice

Prepare: You're going to experiment with an inkblot. While alone at your desk, find an old ballpoint pen and a fresh piece of white copy paper. Many pens will unscrew, but you may need to carefully break it open to access the tube that holds the ink. With a scissors, cut the end of the tube off to expose the ink.

Act: Hold the ink over the piece of paper and let it drip. Carefully blow on the drop of ink and observe as it splatters. Then, respond to the questions listed above under the "Inkblot Appreciation" activity.

Reflect: Think about the activity. Reflect on how you might introduce this to the children. You will obviously need to purchase ink rather than break open pens, but what extra supports are needed to organize materials, for cleanup, and so on?

Art Materials: How Can We Stretch Our Dollars?

Emma isn't sure what to do when the children waste art materials. Her program has a limited budget, so her director rations glue, tissue paper, construction paper, and all the open-ended materials that the children love. How can she provide the children what they need and keep the art center interesting without blowing out the budget?

Materials for art making can be expensive. Good quality pastels, crayons, paper, collage materials, and scissors are not inexpensive, and they are consumables. Children use and abuse these materials and tools, so they need to be replaced regularly. Children typically love to use massive amounts of glue, pom-poms, and googly eyes. This chapter highlights solutions for the teacher who wants to restrict the use of materials to two googly eyes and three pom-poms per child. While brand new materials from a catalog are fun, opportunities to find and utilize free and recycled materials abound.

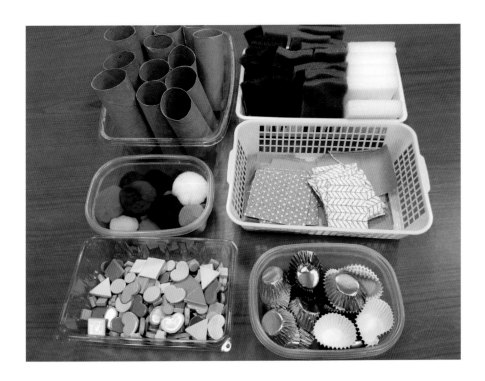

Open-Ended Art and the Challenge of Materials

Young children like to use a lot of everything. When they need just a handful of crayons, they'll dump out the whole box to find the perfect colors. When they need to cut out a small circle, they will cut it from the center the paper. This is their nature. It may seem like they're being wasteful, but they aren't thinking about using up the stuff. They may simply like looking at the large pile of materials, they may like the feel of the materials in their hands, or they may like the action of getting the material off the shelves. Have you ever watched a young child use a paper towel dispenser with sensory devices? Some children will repeatedly get a paper towel because the machine appears to be magical. They could be wondering, How many towels are there in there? Is there an end? Again, a problem to be solved.

Recently a training was offered to a large group of early childhood professionals on the topic of this book, open-ended art. After an hour of explaining all the fundamentals in large- and small-group discussions, the participants circled back to the topic of open-ended art. They were reminded that when an art center is available, some children may want to use multiple googly eyes. One participant couldn't get past that statement and asked repeatedly, "Why can't we just pass out two eyes per child and leave it at that?" She felt that if children were creating faces, the faces could have only two eyes, so the children needed only two googly eyes.

Of course, children need only two googly eyes to make a face, but art should be about the children's interpretations and expression. Perhaps a child was looking at images of the artist Picasso's abstract faces and was experimenting. Or perhaps the child was attempting to create a profile or wasn't even creating a person but an imagined creature from space. To answer the participant's question about googly eyes, readers may need to revisit many of the topics previously discussed, though it comes down to four basic principles:

1 If early childhood educators are offering open-ended art materials in an art center, then there is no need to restrict the amount a child uses of any specific item.

2 Having the entire group of children completing art at the same time and rationing items throughout the day is time intensive and unnecessary.

3 Some items seem more expensive (such as googly eyes) than others, but if many free, inexpensive, and recycled items are woven into the program, integrating a few new items from a supply catalog should not be cost prohibitive.

4 Why not? What harm will come if a child decides to turn a wolf with two eyes into a crazy monster with eight eyes?

Why is it hard for young children to understand that a little bit of glue will work? When Lena was a newer teacher, she put several containers of white glue in the art center. Later in the day as the children were playing, Lena noticed a three-year-old standing in the art center. The child had a piece of paper on the table and was squeezing glue onto the paper. The child squeezed, and squeezed, and squeezed until the four-ounce container was almost empty. The child put the glue container away and looked at the mass of glue spreading slowly across the paper. Lena asked, "Would you like to look for something to put on the glue?" The child replied, "No," abandoned the picture, and went to another area in the room.

Lena recalls being upset and puzzled. Why would the child just squeeze glue onto paper? She had visions of the year's entire glue supply getting used up in a couple of months. Lena was taking an early childhood course, so she asked her instructor about the child's behavior. The instructor suggested Lena read about Piaget's theory of cognitive development. Recall from previous chapters that Piaget provided some insight into why this child used so much glue. Piaget emphasized the development of schemas. This theory describes schemas as organized units of knowledge. Young children are developing these units of knowledge. Lena realized this child was working on developing a schema for squeezing or emptying.

Observing this child throughout the classroom and the day, Lena realized he was emptying many things, including puzzles and blocks. So what did Lena do? She added various squeezable containers to the water table. She found smaller containers to hold the glue in the art center. Her thinking was that if a child needed to squeeze, less glue, a consumable product, would end up on the paper while the child engaged in a developmentally appropriate behavior. Additionally, Lena spent time in the art center showing children how to use craft sticks and thin paintbrushes to spread glue and apply collage materials. Glue sticks or paste may have been another solution. Lena didn't scold the child who emptied the glue bottle for a developmental need, but instead found a way to support the child's need while conserving consumable supplies.

Using Food in Art Activities

Another concern in our field is the use of food as an art material. There are many art activities that employ food, such as making prints from apples, pouring rice at a sensory table, and stringing colored macaroni. As already discussed, the use of food as an art material for infants is discouraged because it sends them conflicting messages. And using edible food as an art material can be wasteful, especially in a world where many still go hungry. The use of food as an art material

is evaluated differently from one program to the next, but educators shouldn't assume that no one in their program goes hungry. While cutting up apples for an apple print activity may offer children an opportunity to explore apples, teachers need to consider whether there is a better option. The children could easily explore apples as they are cut up for snack. Perhaps there are crab apples that have fallen to the ground. These may not be edible and may therefore be acceptable for creating prints. Think about what items may be available as excess.

Whether buying pasta or rice to color and use in the art center should also be carefully considered. While pasta and rice make fairly inexpensive art materials, families in your community probably eat pasta and rice at mealtime, so the use of these items as activity materials could be viewed as wasteful, and some cultures have very strong feelings about food waste. Consider the families in the community when deciding whether to use food for creating art.

On another note, recipes for modeling clay or dough often call for edible kitchen ingredients. Making modeling dough for young children out of flour, salt, and used, dried coffee grounds is considered acceptable because the food items serve as an ingredient. The edible ingredients are not wasted, because they are transformed into a material that is no longer recognizable as a food item. The modeling dough is then used for a specific purpose.

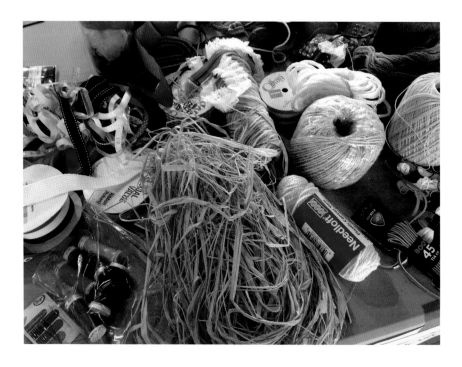

Materials to Recycle

It is important to provide children with a variety of materials for creating art, but it is also reasonable for teachers and programs to be concerned about cost. Making the effort to gather and use recyclable materials can benefit classrooms in many ways. Recycled items can provide a low-cost or free source of found materials that are typically open-ended. Using recycled materials reduces waste in the community and offers opportunities for families and community members to participate in the program or school.

There are many items that can be recycled and used in art centers. Below is a list of materials that could be collected and used in an art center. Always consider children's safe use of materials as you collect items:

- **Paper:** Think about wrapping paper, scrapbook paper, tissue paper, and newspaper. All provide various textures and colors. Some stores or products have unusual colors printed as part of their logo or image. These can provide an array of colors for children's collages and other creations.

- **Cardboard:** Collect tubes, corrugated cardboard, empty boxes, and interesting packing materials. A parent recently bought new kitchen pots that were packed with thin strips and circles of cardboard in various sizes. Shoes and electronics are often packed with molded cardboard forms.

- **Ribbons:** Think of gift packages, gift bags, and folks who are crafters. Small bags from stores often have fabric cord handles. If the bag isn't going to be reused, then the handles can be removed and added to an art center. (Always be aware that ribbons can be choking hazards. Before putting ribbon in an art center, check the lengths. If too long, cut them into shorter, child-safe pieces.)

- **Greeting or gift tags:** Think about the colors, textures, and images that these may hold.

- **Calendars:** In late January, wall calendars often are available at dramatically reduced prices. Many calendars featuring artists, such as Monet or Kandinsky. These calendars are a great way to add images of artwork to your classroom for a reasonable price.

Teachers often request recyclables from families. Teachers can let families know that they are collecting broad categories of recycled materials (for example, "We're collecting different types of papers for our art center") or they can communicate specific lists. Teachers can send notes home with the children and post a large note where parents enter the building. Imagine how many paper product tubes could be gathered if families knew these items were needed? Letting people know what you would like helps contributors collect and donate materials that will be used rather than discarded.

When families understand a program's goals and objectives, they may approach teachers about materials. In one program, a teacher was approached by a father who loved to garden. He had a copy paper-sized box of smooth rocks four inches in diameter. He wondered if his daughter's class could use them. Thinking they might be useful in the center's outdoor area, the teacher, Joel, accepted the donation. Outside, the children were excited about the rocks. Many created interesting designs and piles. One day a child, Roberto, asked if he could take a rock inside to "make an art pet." Joel agreed, and Roberto spent a few days decorating the rock by painting it, repainting it, and adding googly eyes. When other children saw Roberto's creation, they also decided to use the smooth rocks to create art. Then, shortly after one father's rock donation, another family approached Joel. This family was from the Middle East and wanted to donate a box full of small tiles. Again, the children played with the tiles outside, creating beautiful designs on a concrete surface. Eventually these tiles made their way into the art center, prompting Joel to add books about mosaic art to the classroom. He asked the family members to talk with the children about mosaics, which led the children to experiment with mosaic art. These donations of garden rocks and tiles were ways for families to support and engage with the classroom.

Many community members will also provide resources for the art center if educators contact them. Here are some possible community sources for free or low-cost art materials:

- Local newspapers, such as your community paper. Call and ask if they have any end roll paper available. (End rolls are giant rolls of newsprint.)

- Garage or lawn sales. In some locations, it is customary to sell remaining sale items for 50 percent off or to fill a bag for a one dollar. A program director attending a garage sale bought a large tub of Styrofoam spherical, flat, and cube-shaped pieces for two dollars. The director knew his after-schoolers would love creating three-dimensional works of art.

- Local print or framing shops. These shops frequently have large amounts of scrap cardstock or end rolls leftover from their projects.

- The Reusable Resources Association. This association is a national organization that promotes the reuse of materials. It provides a list of centers by location (www.reuseresources.org/find-a-center.html). Often educators can obtain a variety of materials inexpensively or for free. Some locations offer classes and workshops to support the use of recycled materials.

- Member organizations. Let organizations to which teachers belong know what the program is looking for. Members would often prefer to give their unneeded items to children who will use them rather than discard the items.

- Crafters, including sewers, knitters, and scrap bookers. Crafters often have scraps left over from projects.
- Craigslist, or other free, internet-based community bulletin boards. They may have a "free items" page or allow users to post "looking for" requests. If using one of these sites, be very specific about the items you are seeking.

ART APPRECIATION: RECYCLED ART

Many resources that provide directions for projects or crafts made from recyclables are available. Turning plastic shampoo bottles into airplanes (or whatever else the children come up with) could be fun and enjoyable but don't let this limit children's creativity. Encourage children to find multiple uses to be creative as they find uses for recyclables in their art work.

There are many artists that use recyclable materials. A quick search on the internet will produce numerous links with images and information about the artists and their creations. Showing the children images of the artists' work and posting the images in the art center may encourage children. These images could also be used as a discussion starter. Teachers could ask the children questions about the images that would work for any art, such as "What do you see?" "How do you think the artist made this?" "What do you think the artist is trying to tell us?" Most times, an interesting image and a "What do you see?" question are enough to get a lively conversation started.

MAKE CONTRIBUTING AND DONATING EASY

In your classroom, school, or setting, provide a container for people to use to drop off their donations. For bigger or heavier donations from families or community organizations, the teacher or a child's family member may be able to pick up the materials. For safety purposes, always check out any recycled or donated materials. Check for choking hazards, potential allergens, such as wool, and other items that might cause concern. Sending community groups that make donations a thank-you note is a nice gesture. The children could write the note. Also consider including photos of some of the resulting artwork.

When materials such as paper, tubes, and cardboard are collected for the class or settings, it may need to be organized and put away. This work could provide teachable moments for the children, especially preschoolers and schoolagers. Children can assist in the sorting of materials. This provides practice sorting by attribute, such as material type or texture. As materials are being sorted, teachers and children may discuss what the items are, where they came from, and ways they can be used. When materials are added to the art center, the whole class or groups of children could discuss these questions. Doing so will spark ways of using the recycled materials for art making.

Looking at Materials Differently

Teachers should ask themselves, or the children, if there are ways to change or adapt the materials. For example, could a stock material be changed to spark new art making? Paper product tubes can be cut into rings or in half lengthwise. Instead of small pieces of cardboard, include large pieces or empty boxes. Is there a way to display or organize materials to encourage exploration? In one classroom, a teacher regularly included mesh from bags of onions and tangerines in her art center. The children didn't touch the mesh until the teacher wove a couple strips of paper and a ribbon through a bag and added some images of fabric art and weavings to the art center table as a provocation.

A preschool teacher requested that families collect envelopes to use during a community helper theme. This teacher thought children could use the envelopes in the dramatic play area, to be mail carriers or to create a post office. One day as she and two of the children were sorting the "contribution box," one child noticed that some of the envelopes had windows. The child asked, "Can I have the window? I want to make a goldfish picture." The teacher and the child removed the front panel of the envelope. Later that day the child proudly showed his goldfish picture using the envelope "window," some fish stickers, and blue tissue paper. When other children saw his picture, they were inspired and the demand for envelopes windows increased. In the art center, the children explored how they could incorporate the windows.

Personal Reflection and Practice

Prepare: Select a new collage item, such as googly eyes or small wood pieces.

Act: During learning center time today, leave out the new materials. Do not limit how many the children use. Observe what happens.

Reflect: How many pieces did the average child select? How do you feel when children pick up multiple pieces of an art materials? Do you feel that they materials are wasted?

Art Appreciation: I Don't Know Much about Different Artists, So How Do I Teach Children to Appreciate Art?

Janet doesn't know that much about famous artists or famous works of art, so she doesn't feel comfortable bringing them into the classroom. "Besides," she surmises, "the kids don't really need to know those things. Right?"

While many teachers are unfamiliar with different forms of art, many of the early childhood art guidelines and standards encourage teachers to expose children to art and teach them how to appreciate art. Unless teachers are trained artists or have studied art appreciation, however, it may be very hard to put that into practice. That's okay! This chapter explores methods to encourage art appreciation in children through activity-based learning.

Rather than the open-ended activities offered in previous chapters, some art appreciation may begin as a structured activity, but it is not intended to remain structured. The activities could be introduced in various groupings then continued as one of the self-selected options available during free play or learning center activities. School-age children might begin with a whole group activity, then move into small groups or pairs to complete the activity. The goal is to ensure that children are actively engaged in all aspects of the activity.

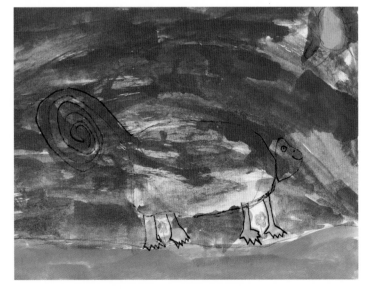

Young children learn many skills when they are actively involved in these activities, and increased communication skills are just one of the positive outcomes. When children are encouraged to work together in pairs or small groups to solve a problem, create something,

or admire a piece of artwork, they learn communication skills that will benefit them in many aspects of their lives. Communication is a twenty-first century skill that is common in all school-based content standards. Communication has many forms, including oral and written, and should be encouraged in formal and informal activities. Art appreciation encourages children to think, feel, and share their thoughts and ideas.

What Is Art Appreciation?

In early childhood settings, teachers traditionally focus on children creating art, but teachers also need to help children think about works of art, how artists create art, and what is expressed through art. Being able to do these things is art appreciation. Art appreciation is not about liking or disliking a specific work of art. It's about taking the time to observe a piece of art and think about its visual elements, such as the colors, shapes, form, and lines that make it unique. It's about finding art in the everyday world, such as book illustrations, outdoor murals, photography in calendars, and designs on buildings. It's about noticing colors, patterns, and shapes and how these qualities are related and connected.

All readers of this book are already engaging in art appreciation! Early childhood educators understand the importance of reading to young children. Reading to children is a simple example of supporting art appreciation (National Endowment for the Arts 2004, 39). When reading to children, teachers may encourage them to look at a book's illustrations. Perhaps they will ask the children to think about the illustrations and what they tell a reader. Or teachers may discuss how the illustrator created the images. Asking questions such as these encourages children to notice (that is, observe) and respond to the illustrations. And that is simple art appreciation! Art appreciation helps children develop visual literacy.

Children as young as toddlers are capable of making sense of and appreciating art. Children can use their observational skills to appreciate art and share ideas about art. As with other content in a program, think of children's ability and interests. If the children are interested in families, then look for artwork that portrays families. Children that love their pets may enjoy artwork that includes animals. Or, if you are helping the toddlers learn about color, find art that has large images and bright colors. Ann Epstein (2012) describes several stages in art appreciation:

- Toddlers and young preschoolers (sensorial stage): Young children focus on one attribute of art. They respond to art that engages their senses focusing on patterns, colors, and movement.

- Preschoolers (concrete stage): Children this age tend to like realistic art that tells a story and relates to their experiences. They will express opinions on the art based on their interests. Children in this stage can begin sorting art by its medium (photograph versus fabric work or a painting).

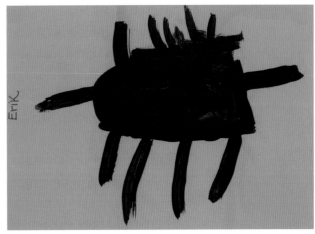

- Kindergarteners (expressive stage): Children this age are beginning to become aware of artistic style and how artists express viewpoints and emotions. At this age, children often discuss characters' and authors' point of view so they are able to discuss an artist's point of view.

These stages summarize many ideas discussed throughout this book and will help teachers as they plan learning outcomes and activities for art appreciation.

Art Images: Where Do I Find Them?

Art appreciation begins with the search for and examination of art. Today's children's books feature a wide variety of images and illustrations, so they are an excellent place to begin. A book's images are present to lend context to the story, but they can also provide children with an introduction to art appreciation. All classrooms should have a wide variety of books available to the children. Children's books contain a plethora of images representing various media, such as collage, photography, painting, and prints. The books provide an opportunity to introduce new artistic techniques to the children too. For example, Leo Lionni and Vladimir Radunsky create collages in the books they illustrate. Each artist uses a slightly different college technique; Leo Lionni often uses torn paper in his collages, whereas Vladimir Radunsky often uses different types of paper, such as newspaper, and found objects in his collage illustrations.

After reading a book with multiple collage images, a teacher could discuss the artist's techniques and ask the children questions, such as "How do you think the illustrator created this image?" The children could make some guesses, and the discussion could continue as the children move into the art center, where they could experiment with materials such as torn paper or newspaper scraps.

To continue to encourage children's art appreciation, every book center should include a few books that have earned the Caldecott Medal, which is awarded to the artist of the most distinguished American picture book for children. Children's books can be displayed in the art center as a source of

inspiration. Visit the American Library Association website for a list of all the award-winning books. The Recommended Children's Books and Resources list on page 141 includes additional picture book examples.

Many art museums provide images of famous works of art from their collections on their website. Examples include the National Gallery of Art, the Metropolitan Museum of Art, the Albright-Knox Art Gallery, and the Smithsonian American Art Gallery. The public can browse these collections free of charge, so look for something that will be visually appealing or interesting to the children in the program; it shouldn't take long to find something likely to catch their eye. Once you have selected a work of art, take some time to learn a little bit about the artist. Spend time looking at the "educator's resources" on the museum's website too. This area often contains lessons and helpful hints. Many of the lessons provide background information and indicate a recommended age, grade, and content area suggestions.

Print out some basic information about the work of art and the artist that will provide context for the children; information about artists and additional images of works by the selected artists are readily available online. Depending on the

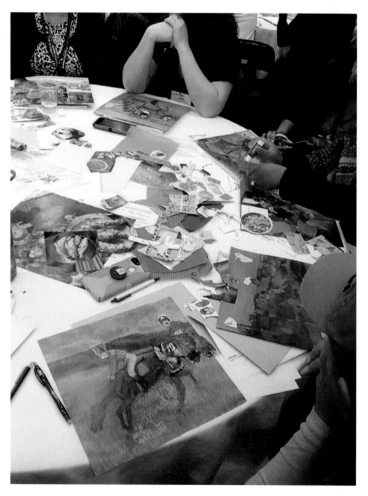

age of the children, share information about the artist's life, about the time period when the art was created, and about the different mediums used. It's okay if you're not an expert as long as you are honest with the children. Don't make guesses or provide interpretations unless you are knowledgeable. Instead, share what you find and learn along with the children. Ask the children questions, encourage them to think about the artwork, and if they seem particularly interested in something, use that as an opportunity to dig deeper. The children are unlikely to recognize the different time periods, or the difference between works of art that were painted during the Renaissance period versus pictures painted last week, but they may notice the different style, the clothing, the shapes, or the mood that is created by the artist. As children begin to understand the different movements, styles, and techniques, they may begin to develop, evaluate, and improve their own artistic work.

Strategies for Practice

As children grow and develop, strategies for art appreciation become more detailed and specific. Starting with infants, it may be enough to provide a few appealing pieces of framed artwork and some board books that show beautiful artwork. For toddlers, teachers should begin to draw attention to the artwork in books and artwork in the environment, for example posters or framed artwork on the walls. Encourage them to use their senses as they observe patterns, colors, and movement in the world around them. Older toddlers can begin to engage more formally and respond to simple questions about art. For preschoolers, more formal activities can be introduced to the whole group, such as during group time. The activities should last no more than five to ten minutes, however, as part of the daily routine.

School-agers are much more adept at a variety of cooperative learning techniques. As with preschoolers, teachers can introduce the activity to the children in a large group. Then the children can break up into small groups or pairs to share with each other. After about five minutes of paired discussion, the children can come back to the group to report what they noticed. The first day the activity may seem a little confusing to them, but school-age children like to follow a routine, so if the art appreciation activity becomes a regular part of the schedule (such as Free Art Friday), the children will get used to the activity, and within a few weeks, they will know exactly what is expected and how to proceed.

The following activities could be introduced in many ways depending on the age and ability of the children in the classroom, but some general recommendations have been provided. For each activity, please begin by sharing a selected work of art. Read to the class about the artist. Then select one of the following activity-based approaches:

Simple description: Look at the artwork. Ask the children to describe what they see. What do they think is happening in the picture? What do they find interesting or unusual? Model questions, allow time for answers, then display the picture somewhere in the classroom for further study.

Detailed description: Ask the children to look at the artwork and to zero in on the artistic style. This is a great option for abstract art, or art that does not include recognizable images. Teachers can help children focus their attention on what is visible and observable and what is subjective or interpreted. This can be done through drawing the children's attention to details and asking questions. As the children share their thoughts about the details or story in artwork, teachers can

help the children provide evidence from the artwork and point out when the children make interpretations based on the artwork. Other questions to ask include are the lines solid or intermittent? Wide or narrow? Long or short? This activity is particularly effective if teachers are planning to introduce different painting materials in the art center (such as brushes of different sizes or rags in lieu of brushes).

Interpretation: Select a work of art with some historical significance. This technique could be used with a group of school-age children studying a specific time period, such as the Civil War. Ask the children to try to put themselves in the artist's shoes. What do they think the artist was trying to say or express through the artwork? Can they interpret the artist's message within the context of the time period?

Dramatic play and interpretation: Select some artwork that appears to depict several characters or exhibits objects in motion. Ask the children to act out some of the forms or shapes they see in the art. What do they think the characters are doing or saying? When possible, provide opportunities for children to extend this activity into the dramatic play area by adding props. For example, print a copy of the faces that are visible in the artwork, cut the faces out, attach them to cardboard, glue on a craft stick, and encourage the children to act like the characters in the painting. If possible, provide props related to the artwork.

I spy something: Select a large piece of artwork that has many shapes, characters, or leaves a lot of room for interpretation. Ask the children to look at the picture until they spy a specific item. They should name what they spy and ask a partner to find that item within the artwork (for example, "I spy a laughing dog").

See the setting: Look at the artwork. Ask the children to focus first on the setting of a work of art, and then on the characters in the artwork. Ask them to imagine someone different in the setting. For example, if the artwork depicts a beautiful park with people lounging by a pond, the children may picture what would happen if one of the people were replaced by a giant beetle lounging by the pond. The children could find pictures of alternative characters in magazines, or they could draw them and place them in the setting. Or the children could place the characters in an alternate setting, such as a different work of art.

Before and after: Select a piece of artwork with interesting characters or an active scene. Look at the artwork together. Have the children imagine what might have been happening just before or after the depicted scene. Try this with Edward Munch's *The Scream.*

See-think-wonder: This is a "visible thinking" strategy from Project Zero that was developed to help children look at and discuss works of art. It asks children to use their observation skills and provide evidence for their responses. Individually, in small groups, or with the whole class, a teacher should guide the child or children through three questions: "What do you see?" "What do you think about that?" and "What does it make you wonder?" (Harvard Graduate School of Education 2015).

Although helpful, it doesn't take any special training in art history or art appreciation to encourage the children to think about artwork in this manner. All you really need to do is to find some interesting works of art, complete a little background research, and expand your comfort level to be prepared for a discussion that could go in a number of directions.

General Strategies for Visiting Art Museums

Many early childhood educators and parents cringe at the thought of bringing young children to an art museum, full as they are of too many "no touching" areas but lots of things that look appealing to young hands. Successful trips to museums require thoughtful planning. The following steps will help teachers plan an enjoyable trip:

Do your homework: Plan the visit based on children's interests. If you have not been there recently, visit the art museum in advance. Think about what areas would be interesting to visit and don't try to see everything in one day. Narrow the visit to a specific genre, artist, or theme. Many museums' websites contain resources such as lesson plans, activities, and book recommendations.

Preplanning: Read a book related to the museum visit to the children. You could select books on a specific topic or about visiting a museum in general. If possible, provide a number of books that include works

of art. (See the Recommended Children's Books and Resources list for some options.) Check the museum website for teacher resources or images of some of the art you will see. Many museums have planned tours available for school groups. Some museums require a certain ratio of adults to children. It may be helpful to provide an overview of information about the museum to any adult volunteers who will be joining the group.

Preliminary activities: Museum gift shops often have postcards of artwork available for purchase or you may find artwork on the museum website. Show the children some of the artwork they will see as an introduction. Children can guess the size of the artwork. They can practice "looking but not touching" different objects. One teacher set up a museum in the child care center so the children could practice looking but not touching before visiting a gallery.

During the visit: Talk about the works of art. In small groups (you'll need some chaperones here), the children can use the postcards or printouts of the museum artwork in a scavenger hunt. Remind children that the "art hunt" is not a race to locate the works. Ask each child to point out their favorite work of art and if allowed, take a picture of the child next to it.

After the visit: Once you return to the program, use pictures, postcards, and museum maps to reflect on the trip. Help the children recall details and hear others' perspectives. Ask each child to share their favorite picture and to explain why it was their favorite.

Follow-up activities: These activities could take many forms. One option would be to create a book about the group's trip to the museum, or one titled "Our Favorite Art" that incorporates the pictures of the children standing near their favorite piece of art. Another could be to use the postcards of artwork to create a matching game. One class of preschoolers had such a great time on their museum trip, they decided to make their own museum! The children carefully considered which of their own pieces of artwork should be included. Several children noticed that art in the museum had signs telling visitors about the artwork and its title. Their enthusiasm inspired this group to children to create cards; with their teachers' help, the children dictated or printed cards containing the art's title, the artist's name, and the materials. Invitations were created to invite families and other classes to their museum. This was such a hit that the local library hosted the children's museum.

Personal Reflection and Practice

Prepare: Visit a local art museum or select an online alternative that provides photographs of artwork. Select a piece of art. Look up the artist and learn something new about him or her.

Act: Now look at the piece of art you selected. Develop a list of the things you notice. What portion of the artwork do you find unusual or interesting? What do you think the artist was trying to say? Go one step further and select one of the activity-based approaches listed above. Respond to the guiding questions.

Reflect: How do you think children will respond to this simple activity? What portion of the artwork you selected do you think they will notice?

What's Next?
Now That I See Art Differently,
Where Do I Find New Ideas?

As Marta reads this book, she writes notes and highlights some ideas. Finally, she turns to the last page. "Well," she thinks, "there are lots of ideas here! I want to try all of them." She decides she will mark the ideas and then begin gathering materials and books to use in her classroom. Marta excitedly gets some sticky notes and starts marking her favorites. As she finishes she looks at the sticky notes. There are quite a few. "Oh, no," she sighs. "Where do I start?'

You've read the book and we're hopeful you're excited about art. But there are so many online sites boasting the "best" art projects, as well as magazines, bloggers, and educators telling the world what is important. There are professional organizations and books full of suggestions. So where does a teacher start?

In this book, we discussed the cycle of curriculum and planning, reviewed what art looks like for each age group, and explored advanced techniques and art appreciation. We shared ideas for planning the environment and selecting materials, and we provided instructions for creating learning outcomes, instructions for assessing these outcomes, suggestions for various activities for creating, and prompts for ways to begin appreciating art. Now think about yourself and your ability to promote open-ended art in your program or classroom. Are you ready? If not, what other resources are available to help you gain additional knowledge? This chapter offers suggestions for navigating resources as well as some final ideas on what first steps you might take toward more open-ended art in your setting.

Resources: Web

Many art ideas available on the internet are based on curriculum or theme kits or structured projects. When searching the internet for "art projects," the search will frequently show lots of results from Pinterest or the "25+ Best Art Projects for Infants"—or Toddlers, or Preschoolers site. There are also structured art curriculums kits or theme kits available for online purchase. Looking through these

sites or kits, teachers can find a variety of ideas. Some ideas are for structured crafts while others suggest sensory-based or open-ended projects. Using information from the chapters of this book, teachers can evaluate the online suggestions and kits for best practices. There are some questions that teachers can ask about the online options:

- Does the idea allow children to control the situation or provide opportunities for choice? Frequently the online suggestions are closed-ended craft projects where children follow certain steps to create an exact product, for example, a painting of a child's hand to create a flamingo. Closed-ended crafts are probably not the best use of time in the classroom.

- If someone were writing a learning outcome for an idea from the internet, would the learning outcome promote children's exploration of materials, expression, perspective, or appreciation of art, or would the learning outcome be to create a specific product that looks like the image on the website?

- Does this activity or project support the suggestions found in the planning documents you use, such as Head Start Early Learning Outcomes Framework or your state's guidelines or standards? Think about how the outcomes would be measured.

Throughout the early chapters of this book, we analyzed some classroom scenarios and provided suggestions and resources. In the Recommended Children's Books and Resources list, additional websites for organizations and museums are given. These represent some of our favorites, and we hope you will consider looking at them as you search for information. If you locate other sites you want to use, Trio Training at the University of Washington suggests criteria you could use for assessing the quality of the information provided on the websites, including accuracy, authority, objectivity, and coverage (Trio Training 2011). Generally, information located at .edu, .org, or .gov sites is professional and preferred for accuracy. Individuals also publish sites that provide lots of teaching ideas. Ensure that you know who is providing the information and what their credentials are. Also notice if the site is heavily advertising certain products. When a site has links to a lot of products, remember that endorsements often include financial incentives for the website creator.

Resources: Books and Libraries

There are thousands of new books published each year. It would be impossible to keep up with all the books that might be useful as teachers look for new ideas. Throughout this book and in the Recommended Children's Books and Resources list, a variety of children's books about artists and techniques, and fictional

stories about creating art have been suggested. These book ideas may help get you started.

Public libraries are a great place to gather information. Many libraries have a children's section and professional staff that specialize in children's material. These helpful people can direct you to books about art techniques and artists and locate lists of award-winning children's books for you. The American Library Association website includes lists of notable books and links to various resources.

Resources: Professional Development

In addition to locating ideas for art materials and activities or professional development, you may also be thinking about learning additional techniques. Chapter 12 in this book provides several ideas to get you started. There are other resources that can provide suggestions and training. Many national organizations, such as NAEYC, the National AfterSchool Association, Zero to Three, and others, hold national conferences, provide webinars, and share various resources on their websites. Many of these organizations have regional or state chapters that also sponsor workshops and conferences. These types of events offer teachers a chance for professional development and to meet other early childhood educators.

There are many video sources on the internet. The Khan Academy, for example, offers many videos about art history and artists' techniques. We suggest you choose a material and an idea and begin by trying to create something. Throughout the book, we have emphasized that creating art is about the process. This applies to your attempts with various materials and techniques; some will work well, with results that capture your ideas or feelings, while others will not be as successful. That's okay. Engaging in creative art will model your interest to the children and provide you with a new form of expression. Experimenting with materials and techniques will also allow you to think about what children experiences as they engage in the process.

So What Can I Do?

Now that you've finished this book we hope you are excited to implement the ideas you've read and thought about. If you have not been encouraging open-ended art in the classroom, we hope you will take one or two ideas from the book to try. Instead of providing a specific craft, try putting the materials out and letting the children experiment. If the children have not had this type of opportunity before, it may take a while before they are comfortable with creating art. After all, they may not have had the chance to think about what to do with the materials.

Think about ways to support children as they move toward open-ended art. A key idea about planning is knowing your children. Where are they developmentally? What are their interests? Reflect on the answers to these questions.

If you are already incorporating open-ended art, congratulations! We hope this book has reinforced your philosophy on art and provided you with a few new ideas to try. Perhaps you will decide to look at the environment rating scale or state standards' documents for your age or grade level for additional ideas.

Art appreciation may be another area to think about as you complete this book. Do you have images of artwork in your classroom or setting in the form of images and books? Do you regularly discuss artworks with the children, including well-known works and the children's own work? Do you display children's art in the classroom or setting? These may be places to start implementing this book's ideas.

When thinking about adding materials, trying new techniques, or including art appreciation, remember to reflect diversity. Include materials that allow children to represent themselves or the people in their families or neighborhoods and that represent the cultures of the families and community. Ensure that all children can engage in art making with various materials, modifications, and accommodations.

We recently met a teacher named Elisa who had a hard time separating from the theme-related coloring pages she liked to leave in the art center. Elisa understood open-ended art and had an art center available, but it was difficult for her to leave behind the structured projects she was used to providing, and she insisted the children preferred the coloring worksheets to an open-ended art opportunity. We challenged Elisa to develop an informal study to find out if this was true. One day she left out a stack of plain paper next to the stack of photo-copied theme-based coloring pages. She was amazed to find the children went right for the plain white paper. She reported that some of the children began to color the photocopied worksheet, but when they realized how much fun it was to do their own thing, the stack of coloring sheets literally ended up on the floor to make room for everything else! Elisa realized that she was making a lot of presumptions about the art materials the children preferred. Over time she continued to make changes and reflected on both the strengths and challenges that come with change.

Finally, we would like to encourage you to try an idea from this book. Think of challenges that may be present in your room or program as an opportunity to try something new or different. After all, art is all around us.

Personal Reflection and Practice

Prepare: Throughout the book we've suggested many reflections. Choose a task from one of the chapters that you found difficult to complete. Reread the task's Personal Reflection and Practice. Think about what you need to complete this task. Materials? More information? Training on a technique?

Act: Take a bit of time and use your research skills to locate the needed item or items from the Prepare step of that task. When you're ready, complete this task.

Reflect: Now review the task you completed. Reflect on the steps you took to do the task. Now think about the children you work with (or the age group you want to work with) and figure out the steps to apply one new idea to promote open-ended art.

RECOMMENDED CHILDREN'S BOOKS AND RESOURCES

Picture Books about Creating Art

Alborozo, Gabriel. 2014. *Let's Paint!* Crows Nest, N.S.W.: Allen & Unwin.

Baker, Alan. 1999. *White Rabbit's Color Book.* New York: Kingfisher.

Carle, Eric. 1998. *You Can Make a Collage: A Very Simple How-To Book.* Palo Alto: Klutz.

Kohl, MaryAnn F., and Kim Solga. 2008. *Great American Artists for Kids: Hands-On Art Experiences in the Styles of Great American Masters.* Bellingham: Bright Ring Publishing.

Krumbach, Monika. 2007. *Clay Projects for Children.* London: A & C Black.

McDonnell, Patrick. 2006. *Art.* New York: Little, Brown and Company.

Portis, Antoinette. 2011. *Not a Box.* New York: HarperCollins Children's Books.

Saltzberg, Barney. 2010. *Beautiful Oops!* New York: Workman Publishing Company.

Thomas, Isabel. 2012. *Painting (Start with Art).* London: Raintree Publishers.

Wallace, Nancy Elizabeth, and Linda K. Friedlaender. 2006. *Look! Look! Look!* New York: Two Lions.

——2012. *Look! Look! Look! At Sculpture.* New York: Two Lions.

Wenzel, Angela. 2009. *13 Artists Children Should Know.* Munich: Prestel Publishing.

Picture Books about Art Appreciation

Anholt, Laurence. 2007. *The Magical Garden of Claude Monet.* London: Francis Lincoln Children's Books.

Domeniconi, David. 2006. *M is for Masterpiece: An Art Alphabet.* Chelsea: Sleeping Bear Press.

Freidman, Samantha, Christina Amodeo, and Henry Matisse. 2014. *Matisse's Garden.* New York: The Museum of Modern Art.

Greenburg, Jan, and Sandra Jordan. 2007. *Action Jackson.* New York: Square Fish.

Goldin, David. 2012. *Meet Me at the Art Museum: A Whimsical Look Behind the Scenes.* New York: Abrams Books for Young Readers.

Lehman, Barbara. 2006. *Museum Trip.* New York: Houghton Mifflin.

Look, Lenore. 2013. *Brush of the Gods.* New York: Schwartz & Wade.

Liu, Joanne. 2017. *My Museum.* New York: Prestel Junior.

The Metropolitan Museum of Art. 2014. *The Bunny Book.* New York: The Metropolitan Museum of Art.

Merberg, Julie, and Suzanne Bober. 2005. *Sunday with Seurat.* San Francisco: Chronicle Books.

Bulpitt, Corey, Johnny Maynard Jr., and William Wasden Jr. 2010. *Learn the Colours*: *with Northwest Coast Native Art*. Vancouver: Garfinkel Publications.

Renshaw, Amanda. 2011. *The Art Book for Children*. New York: Phaidon.

Richardson, Wendy, and Jack Richardson. 1991. *Animals*: *Through the Eyes of Artists (World of Art)*. Chicago: Children's Press.

Rubin, Susan Goldman. 2008. *Matisse Dance for Joy*. San Francisco: Chronicle Books.

——2007. *Andy Warhol's Colors*. San Francisco: Chronicle Books.

Rubin, Susan Goldman, and Joseph A. Smith. 2001. *The Yellow House*: *Vincent van Gogh and Paul Gauguin Side by Side*. New York: Harry N. Abrams.

Scieszka, Jon, and Lane Smith. 2005. *Seen Art?* New York: Museum of Modern Art: Viking.

Steptoe, Javaka. 2016. *Radiant Child*: *The Story of Young Artist Jean-Michel Basquiat*. New York: Boston: Little, Brown and Company.

Wiesner, David. 2015. *Art & Max*. London: Andersen Press.

Wing, Natasha, and Julia Breckenreid. 2009. *An Eye for Color*: *The Story of Josef Albers*. New York: Henry Holt and Co.

Winter, Jeanette. 2013. *Henri's Scissors*. New York: Beach Lane Books.

Winter, Jonah, and Ana Juan. 2002. *Frida*. New York: Arthur Levine Books.

Wolfe, Gillian. 1999. *Oxford First Book of Art*. Oxford, United Kingdom: Oxford University Press.

Online Resources

Annenberg Learner uses media and telecommunications to advance excellent teaching in American schools through the funding and broad distribution of educational video programs with coordinated web and print materials for the professional development of K–12 teachers. Please visit www.learner.org and search for their art interactives.

The Association for Library Service to Children provides lists of various children's book awards and links with current and past winners listed. Please visit www.ala.org/alsc /awardsgrants/bookmedia for additional information.

The J. Paul Getty Museum has an online link designed for children. This site contains a variety of online games. The site also contains "Art Scoops," tidbits to read about art, information on some art projects, and links to other resources for educators and families. The link at www.getty.edu/education/kids_families/do_at_home/ provides information.

Visit the KQED Art School for a web video series that introduces contemporary artists who discuss their careers and intentions, then demonstrate hands-on techniques or concepts. Please visit ww2.kqed.org/artschool or search for PBS Learning Media and look for the arts.

The National Association for the Education of Young Children (NAEYC) is a professional membership organization that works to promote high-quality early learning for all young children, birth through age eight, by connecting early childhood practice, policy, and research. Browse their resources for information about best practices in many areas, including art! Visit www.naeyc.org.

The National Center on Early Childhood Quality Assurance provides a list of various state guidelines and standards documents. Please visit https://childcareta.acf.hhs.gov /resource/state-early-learning-standards-and-guidelines.

The NGAKids Zone, National Gallery of Arts Kids Zone, has several interactive art games for children of various ages. The site also contains information on the NGAKids Zone app and has a section for educator resources. This information is located at www. nga.gov/content/ngaweb/education/kids.html.

PBS Learning Media offers a variety of resources connecting learning standards in the arts to artists and techniques. You can select resources by grade, standard, or artistic style. Please visit www.pbslearningmedia.org/.

Pinterest is an online social pinboard. Once you have joined the free site, you can "pin" images of things you want to make, or upload images of activities, projects, or recipes you want to share. Just be careful—many activities that are shared would not be categorized as open-ended art. Visit www.pinterest.com.

REFERENCES

Arts Education Partnership. 2014. "A Snapshot of State Policies for Arts Education." http://www.aep-arts.org/wp-content/uploads/2014/03/A-Snapshot-of-State -Policies-for-Arts-Education.pdf.

Charlesworth, Rosalind. 2014. *Understanding the Child.* 9th ed. Boston, MA: Cengage Learning.

Copple, Carol, and Sue Bredekamp, eds. 2009. *Developmentally Appropriate Practice in Early Childhood Programs.* Washington, DC: National Association for the Education of Young Children.

Copple, Carol, Sue Bredkamp, Derry Koralek, and Kathy Charner, eds. 2013. *Developmentally Appropriate Practice*: *Focus on Infants and Toddlers.* Washington, DC: National Association for the Education of Young Children.

Cryers, Debby, Thelma Harms, and Cathy Riley. 2004. *All About the ITERS.* Lewisville, NC: Kaplan Early Learning Company.

Derman-Sparks, Louise, and Julie Olsen Edwards. 2010. *The Anti-Bias Education for Young Children.* Washington, DC: National Association for the Education of Young Children.

Edwards, Carolyn, Lella Gandini, and George Forman. 1998. *The 100 Languages of Children.* 2nd ed. Greenwich, CT: Ablex Publishing Corporation.

Epstein, Ann S. 2014. *The Intentional Teacher*: *Choosing the Best Strategies for Young Children.* Washington, DC: National Association for the Education of Young Children.

Goldberg, Barry. 2018. "Seeing Meaning, Occasional Paper #31." Bank Street College of Education. Accessed January 2. https://www.bankstreet.edu/scholarly-initiatives /occasional-paper-series/31/part-i/seeing-meaning.

Gunn, Alexandra C. 2000. "Teacher's Beliefs in relations to Visual Art Education in Early Childhood Centres." *New Zealand Research in Early Childhood Education* 3:153-163.

Harms, Thelma, Richard M. Clifford, and Debby Cryer. 2014. *Early Childhood Environment Rating Scale.* 3rd ed. New York: Teachers College Press.

Harms, Thelma, Debby Cryer, and Richard M. Clifford. 2007. *Family Child Care Environment Rating Scale.* Rev. ed. New York: Teachers College Press.

Harms, Thelma, Debby Cryer, Richard M. Clifford, and Noreen Nazejian. 2017. *Infant/ Toddler Environment Rating Scale.* 3rd ed. New York: Teachers College Press.

Harms, Thelma, Ellen Vineberg Jacobs, and Donna Romano White. 2013. *School-Age Care Environment Rating Scale.* Rev. ed. New York: Teachers College Press.

Harvard Project Zero. 2015. "See/Think/Wonder." http://pz.harvard.edu/resources/see-think-wonder.

Isabell, Rebecca, and Sonia Akiko Yoshizawa. 2016. *Nurturing Creativity: An Essential Mindset for Young Children's Learning*. Washington, DC: National Association for the Education of Young Children.

Kansas State Department of Education. 2013. *Kansas Early Learning Standards*. http://www.ksde.org/Portals/0/Early%20Childhood/KsEarlyLearningStandards.pdf.

Linderman, Earl W., and Donald W. Herberholz. 1969. *Developing Artistic and Perceptual Awareness*. Dubuque, IA: WM. C. Brown Company Publishers.

Louisiana Department of Education. 2013. *Louisiana's Birth to Five Early Learning & Development Standards*. Baton Rouge, LA: Louisiana Department of Education. www.louisianabelieves.com/docs/default-source/academic-standards/early-childhood—-birth-to-five-standards.pdf?sfvrsn=6.

Lowenfeld, Viktor, and W. Lambert Brittain. 1975. *Creative and Mental Growth*. 6th ed. New York: Macmillan Publishing Company.

Martin, Nicole. 2009. *Arts as an Early Intervention Tool for Children with Autism*. London: Jessica Kingsley Publications.

Michigan State Board of Education. 2005. *Early Childhood Standards of Quality for Prekindergarten*. 2005. Lansing, MI: Michigan Board of Education. www.michigan.gov/documents/mde/ECSQ_OK_Approved_422339_7.pdf.

NAEYC (National Association for the Education of Young Children) and FRC (Fred Rogers Center for Early Learning and Children's Media at Saint Vincent College). 2012. *Technology and Interactive Media as Tools in Early Childhood Programs Serving Children from Birth through Age 8*. Washington, DC: NAEYC. www.naeyc.org/files/naeyc/file/positions/PS_technology_WEB2.pdf.

NAEYC (National Association for the Education of Young Children) and NAECS/SDE (National Association of Early Childhood Specialists in State Departments of Education). 2003. *Early Childhood Curriculum, Assessment and Program Evaluation* www.naeyc.org/files/naeyc/file/positions/pscape.pdf.

National Center on Early Childhood Quality Assurance. 2017. "Early Learning and Developmental Guidelines." https://childcareta.acf.hhs.gov/resource/state-early-learning-standards-and-guidelines.

National Coalition for Core Art Standards. 2012. "Introduction to the Visual Arts PK-12 Performance Standards." www.nationalartsstandards.org/sites/default/files/Introduction%20to%20the%20Visual%20Arts%20PK-12%20Performance%20Standards.pdf.

New York State Early Childhood Advisory Council and New York State Council on Children and Families. 2012. *New York State Early Learning Guidelines*. Rensselaer, NY: New York State Early Childhood Advisory Council and New York State Council on Children and Families. http://ccf.ny.gov/files/7813/8177/1285/ELG.pdf.

New York State Education Department. *New York State Prekindergarten Foundation for the Common Core*. 2011. Albany, NY: The New York State Education Department.

Office of Child Development and Early Learning. 2014. *Pennsylvania Learning Standards for Early Childhood: Infants and Toddlers*. Harrisburg, PA: Pennsylvania Department of Human Services and Pennsylvania Department of Education. www .pakeys.org/wp-content/uploads/2017/11/2014-Pennsylvania-Learning -Standards-for-Early-Childhood-Infants-Toddlers.pdf.

Office of Head Start. 2015. *Head Start Early Learning Outcomes Framework: Ages Birth to Five*. Washington, DC: US Department of Health and Human Services. https://eclkc.ohs.acf.hhs.gov/hslc/hs/sr/approach/pdf/ohs-framework.pdf.

Peot, Margaret. 2011. *Inkblot: Drip, Splat, and Squish Your Way to Creativity*. Honesdale, PA: Boyds Mills Press.

Petty, Karen. 2016. *Developmental Milestones of Young Children*. Rev. ed. St. Paul, MN: Redleaf Press.

QRIS National Learning Network. 2017. "QRIS State Contacts & Map." Accessed July 31. http://qrisnetwork.org/qris-state-contacts-map

Robertson, Katin Oddleifson. 2017. "The Arts and Creative Problem Solving." Accessed July 18. www.pbs.org/parents/education/music-arts/the-arts-and-creative -problem-solving.

Shaffer, Sharon. 2004. *Imagine! Introducing Your Child to the Arts*. Washington, DC: National Endowment of the Arts.

South Dakota Department of Social Services. 2016. *South Dakota Early Learning Guidelines*. Pierre, SD: South Dakota Department of Social Services. https://dss .sd.gov/docs/childcare/early_learning_guidelines.pdf.

University of Washington TRIO Training. "Website Assessment and Evaluation." http://depts.washington.edu/trio/trioquest/resources/web/assess.php.

INDEX